CIRCUS: AN ALBUM
AUTHOR: Granfield, Linda.
Reading Level: 7.3 MG
Point Value: 2.0
Accelerated Reader Quiz # 28260

W9-AKT-900

Lincoln School Library

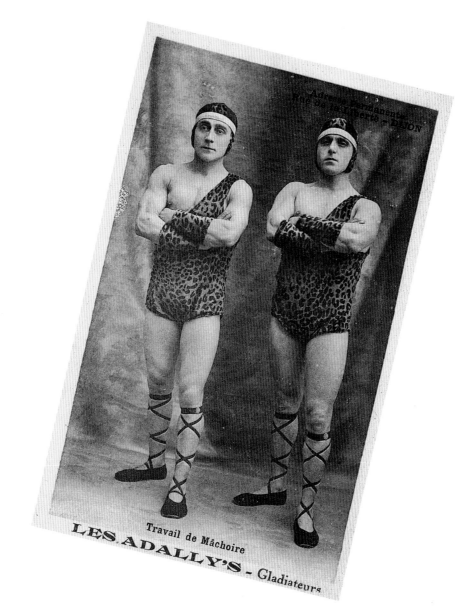

Travail de Mâchoire

LES ADALLY'S - Gladiateurs

LINDA GRANFIELD

C I R

CUS

AN ALBUM

DK Ink

DORLING KINDERSLEY PUBLISHING, INC.

A DK INK BOOK

First Paperback Edition, 2000
2 4 6 8 10 9 7 5 3 1

Originally published in Canada by
Groundwood Books / Douglas & McIntyre

Published in the United States by DK Ink,
an imprint of Dorling Kindersley Publishing, Inc.
95 Madison Avenue
New York, New York 10016

Visit us on the World Wide Web at
http://www.dk.com

Copyright © 1998 Linda Granfield
Jacket art copyright © 1997 Eric Beddows

All rights reserved under International and Pan-American
Copyright Conventions. No part of this publication may be
reproduced, stored in a retrieval system, or transmitted
in any form or by any means, electronic, mechanical,
photocopying, recording, or otherwise, without the prior
written permission of the publisher.

Dorling Kindersley books are available at special discounts
for bulk purchases for sales promotions or premiums. Special
editions, including personalized covers, excerpts of existing
guides, and corporate imprints can be created in large
quantities for specific needs. For more information, contact
Special Markets Dept., Dorling Kindersley Publishing, Inc.,
95 Madison Ave., New York, NY 10016; fax: (800) 600-9098.

Printed and bound in China

Library of Congress Cataloging-in-Publication Data

Granfield, Linda.
Circus : an album / by Linda Granfield.—1st American ed.
 p. cm.
Originally published: Toronto : Douglas & McIntyre, c1997.
Includes index.
Summary: Traces the history of circuses from the time of
ancient Egypt and Greece through their evolution in
eighteenth-century Europe to the spectacles created by P.T.
Barnum and other modern-day showmen.
ISBN 0-7894-2453-3 (hc) / 0-7894-2661-7 (pb)
1. Circus—History—Juvenile literature. [1. Circus—
History.] I. Title.
GV1801.G79 1998 97-33523
791.3'09—dc21 CIP
 AC

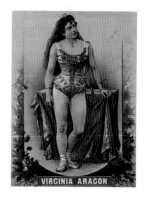

VIRGINIA ARAGON

In memory of my mother,
Barbara Granfield, who filled my
childhood with magic, laughter
and love.

The Circus Rose

Acknowledgments

My sincere thanks go to the many people who enriched this book through their enthusiastic offerings of information, recollections and archives; in particular, to Bill and Roberta Ballantine, Sarasota, Florida, who welcomed a total stranger into the warmth of their home and hearts.

The following people have also given generously of their resources: Patsy Aldana; Archeological Museum of Barcelona, Spain; Arlette Anderson, Royal Winnipeg Ballet, Manitoba; Jo Bannatyne-Cugnet; Bata Shoe Museum, Toronto; Big Apple Circus; Dr. Gordon Brown, Edmonton, Alberta; Lorne Brown; Laura Bruce, Mackenzie Heritage Printery Museum, Queenston, Ontario; Shirley Brundrett, Brundrett's, Victoria, Australia; Catherine Bush; Jane Buss; Jeffrey Canton; Cirque du Soleil; Paul Cox, National Portrait Gallery, London, England; Don and Stephen Cribar; Lynn Westerhout Cutler; Fred Dahlinger, Jr., Circus World Museum, Baraboo, Wisconsin; Kathryn DeCarlo, Royal Ontario Museum, Toronto; Ecole Nationale de Cirque, Montreal, Quebec; Lora Fountain; John Fugate, International Circus Hall of Fame, Peru, Indiana; George R. Gardiner Museum of Ceramic Art, Toronto; Maureen Granfield; Hertzberg Circus Museum, San Antonio, Texas; Nancy Heywood, Peabody Essex Museum, Salem, Massachusetts; Linda Hodgins; Ron Jobe; The John & Mable Ringling Museum of Art, Sarasota, Florida; Campbell S. King; Main Space School of Circus Arts, Toronto; Dr. Jean Marmoreo; Linda McBryde, Buchanan, Virginia; Metropolitan Toronto Reference Library; Musée de la publicité, Paris; Musée des arts et traditions populaires, Paris; Museum of Fine Arts, Boston; New Pickle Circus; Ken Nutt; Kathryn O'Dell, Clown Hall of Fame, Milwaukee, Wisconsin; The Osborne Collection of Early Children's Books, Toronto Public Library; Robert S. Pelton, Barnum Museum, Bridgeport, Connecticut; Piazza Armerina, Sicily, Italy; Posy; Jan Shoor Potter, Troy, New York; Ringling Bros. and Barnum & Bailey Combined Shows, Vienna, Virginia; Scott Robson, Nova Scotia Museum; Michael and Marion Seary; Ken Setterington; Shari Siamon; my family, Cal, Devon and Brian Smiley; Michael Solomon; Spear's Specialty Shoe Co., Springfield, Massachusetts; Robert Sugarman; Shelley Tanaka; Cora Taylor; the Thiessen family; the Toronto *Star*; Tufts University, Medford, Massachusetts; University of Toronto; Deborah W. Walk, Ringling Circus Museum, Sarasota, Florida; Whitney Museum of American Art, New York City; Peggy Williams, Madison, Wisconsin; Mary Witkowski, Bridgeport Public Library, Connecticut.

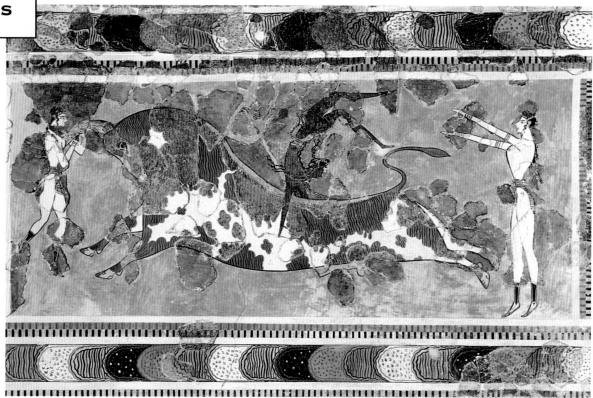

Leapers vault over a bull's back in this 1600 B.C. fresco from Knossos, Crete.

Ancient Front Row Seats

Exciting clues about the colorful world of the circus have appeared through the centuries, but historians have trouble coming up with one moment in history when the circus was born. Animal and acrobat acts date back to 2400 B.C. Ancient Egyptian art shows that acrobats, jugglers, clowns and long parades entertained Egyptian nobles and citizens. In fact, Queen Hatshepsut brought to Egypt monkeys and giraffes—animals later seen in circuses around the world.

Almost four thousand years ago, on the Greek island of Crete, audiences filled arenas (called Bull Courts) to watch young Minoan men and women grab the horns of charging bulls and vault over the animals' heads. These routines of backward somersaults and handstands were cleverly designed but extremely dangerous.

Bull leapers often became popular and wealthy "stars" of Minoan society. Performers wore embroidered clothing, bracelets, elaborately curled hairdos and makeup. Such colorful costuming continued to be a part of entertainment throughout history.

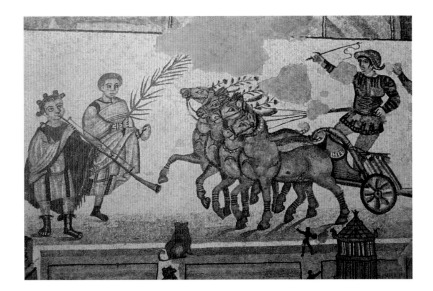

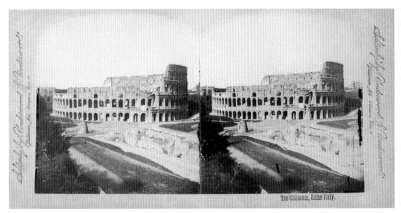

The exciting acts performed centuries ago in circuses, like the Colosseum (right), were captured in colorful mosaics in Italy and Spain.

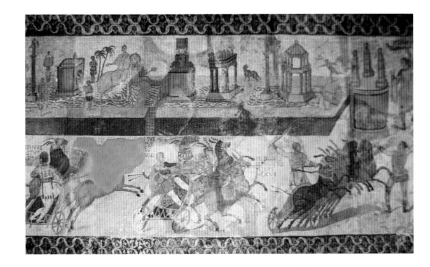

Bread and Circuses

Decimus Junius Juvenalis, a Roman writer born about A.D. 50, once said that what people really wanted was *panem et circenses*—bread and circuses. In other words, as long as people were fed and entertained, they would be happy (and therefore less of a problem for their leaders!). No doubt Juvenalis, like other Romans, took part in the nearly 175 days of festivals and celebrations that were observed *each* year.

During the festivals, entertainments were held in huge roofless buildings (called circuses) that could hold as many as 250,000 people. Spectators sat under the blazing sun to watch the show, which could last all day. Events included chariot races with speeding horses, wild animals displayed in cages, and fierce, to-the-death battles by armor-clad gladiators. Merchants sold pastries and beverages. Nearby booths featured astrologers, jugglers and acrobats.

Although these Roman spectacles seem similar to the modern circus, historians hesitate to credit Rome with the birth of the circus. The bloody battles between animals and men offered a chill much different from the one we experience when we watch a tightrope walker carefully travel across a thin cable.

Early Influences

A curiously calm spectator watches feats of sword-swallowing and magic at this 1830s village fair.

During the Middle Ages, people spent most of their lives living and working in one small community. There wasn't the time, transportation, adequate roads or money for travel. Scholars estimate that the average person saw no more than one hundred people in his entire lifetime. (The average person today has seen hundreds of people before his first birthday!)

Imagine the excitement, then, when traveling entertainers arrived in the village with dancing bears and dogs, acrobats, jugglers *(jongleurs)* and singers. The performers would draw their wagons into a wide circle and use them as stages. Jesters teased the audience with riddles, jokes and songs. In France, troubadours *(trouvères)* sang songs for a fee. Contortionists caused gasps of wonder as they twisted their bodies into incredible shapes.

Meanwhile, pickpockets moved through the crowds, and mountebanks (quack doctors) advertised the miracle cures their wonder medicines would bring to the person who paid just the right price for a small bottle or bag. People felt the push to buy and see, for the traveling entertainers would be gone in a day, maybe two.

Booths and tents were set up at the edge of the village. "Come and see the rare unicorn," a crier would yell. "The only one in the world, and yours to see—for a small fee." The unicorn was just a horse with a fake horn, and often onlookers knew they'd been tricked. But people lined up and paid anyway.

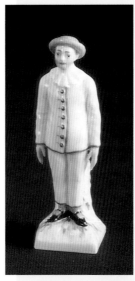

This porcelain Pierrot (a French version of the Italian character Pedrolino) was made in Germany in 1780.

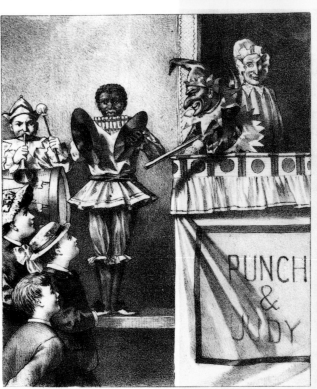

Our Old Friends.

Land sakes alive ! if here ain't Punch and Judy ! what a treat,
These dear old friends, these queer old friends and favorites to meet !
Bring Toby and the Baby, and the gallows for Jack Ketch ;
It makes the children laugh to see Punch hang that wicked wretch.

19

Italian Comic Relief

While the *jongleurs*, jesters and troubadours of the 1500s were entertaining crowds in England and France, *commedia dell'arte* (comedy of art) was causing laughter in Italy. Traveling entertainers performed folktales familiar to their audiences. They told stories using actions, not words, and these traditional mime movements are still used by clowns today.

Italian troupes toured Europe, England and Russia. Among the characters were the beautiful Columbine, the drunken doctor and the servant Pulchinella. (In England, Pulchinella became Punch, the puppet who bullied Judy in street shows.)

Lazy Pierrot, or Pedrolino, was not very intelligent but somehow managed to see the foolishness of others. His very sober, sad expression was later adapted by tramp clowns (page 71).

But the most famous *commedia* character was the masked servant, Harlequin. His name and his bright costume of multi-colored patches have been used by clowns ever since.

The Father of the Modern Circus

By the 1700s, traveling fairs weren't as popular as they had been. But the situation was about to change. In 1742, the Englishman who came to be called the Father of the Modern Circus was born.

Philip Astley ran away from home when he was a teenager. He joined the army and became a great horseman. By the time he was twenty-five, Astley had retired from the army. He bought a London field called Halfpenny (pronounced *haypenny*) Hatch, where he held open-air equestrian shows.

It wasn't long before Astley built a two-story wooden building over the ring's entrance and constructed viewing stands covered by peaked roofs. Astley's New British Riding School was officially opened in 1770.

Students at the school spent the mornings learning new equestrian skills. In the afternoons, however, people paid to watch the riders perform. Astley himself awed the spectators with his trick-riding skills. He'd ride standing up with one foot on the saddle and the other foot on the horse's head, and all the while he would swing a sword above his head. The crowds went wild.

Astley was a shrewd businessman, and he soon hired some unemployed acrobats, rope walkers and musicians to further entertain his audiences. Business boomed, and Astley was invited to take his show to France. His troupe even performed at the famous palace of Versailles for Marie Antoinette, the queen of France.

In London, Astley later opened the Royal Amphitheatre of the Arts, where three chandeliers, each burning five hundred candles, drenched the stage and the arena with light. There was a band and a strongman who lifted a table loaded with people above his head. Eventually, Astley established eighteen circuses in Britain and Europe. He died in 1814, but his vision and skill influenced generations of circus owners to come.

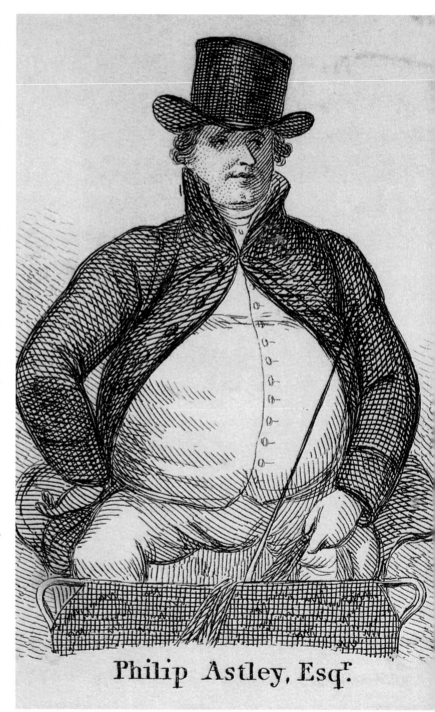

Philip Astley, Esq.ʳ

Andrew Ducrow (1791-1842)

Andrew Ducrow was one of Philip Astley's students, and he took over the Amphitheatre operation in 1823. He is credited with being one of the most exciting figures in circus history. His most famous act—"The Courier's Ride to St. Petersburg"—shows why.

The act told the story of a courier riding from London to St. Petersburg, Russia. Ducrow began by standing astride two horses. Then more horses rode between the first two horses—and Ducrow's legs! As the horses passed through, Ducrow picked up their reins until he was driving three horses in front of him, while still standing on the original two. Each horse was decorated with a flag representing the country Ducrow was pretending to ride through. The routine was so exhausting that Ducrow could not perform it two nights in a row.

But the act lives on. More than 150 years later, in the 1990s, variations of Ducrow's exciting ride were performed by Katja Schumann of the Big Apple Circus.

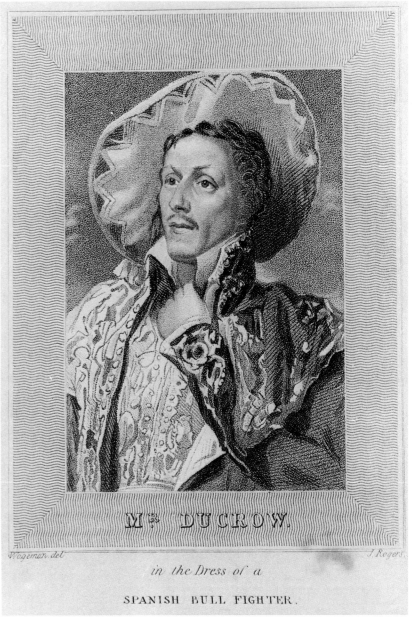

Wageman del. J. Rogers.

Mr DUCROW.

in the Dress of a

SPANISH BULL FIGHTER.

Antonio Franconi (1737-1836)

In France, Philip Astley leased his circus operations to Antonio Franconi. With his two sons, Franconi built the Cirque Olympique into the greatest French circus of its day. The Franconis are credited with setting the diameter of the circus ring at 42 feet (13 meters), a size that remains the standard around the world, although some circuses have recently replaced the traditional ring with a stage, or platform.

The grand entry parade that still opens many circuses was also a Franconi invention. The spectacle, or "spec," introduces the audience to the colors, sounds and characters that will entertain them during the show.

Descendants of Antonio Franconi became one of the most famous circus family dynasties in Europe.

Charles Hughes (17?-1797)

In 1782, Charles Hughes, another star of Philip Astley's equestrian shows, opened the Royal Circus in London. Now Astley had some stiff competition for the crowds' attention and money. Hughes and Astley had a nasty rivalry. They publicly insulted each other, accused each other of

CAUTION!
TO THE
Citizens of Mankato
And the State of Minnesota!
BEFORE
Thursday, the 29th day of June
Peruse and commit to memory the following extracts from the
Chicago TIMES of June 7th and 8th, 1876, and
Take Warning in Time!

cheating, freely snitched each other's ideas and tried to ruin each other's reputations in damaging ads called rat sheets.

In the early 1790s, Hughes took horses and trick riders to the Russian ruler Catherine the Great. His visit inspired the birth of the Russian circus.

Hughes is sometimes credited with being the first to call the circus "the circus." The word *circus*, which simply means "circle" in Latin, was used to identify a place for riding horses in a circle, but would forever after be identified with a magnificent show.

This "rat sheet" broadcasts alleged crimes committed by circus performers upon "defenseless citizens." Such notices were meant to take business away from a competing circus.

TAKEN IN THE ACT.

AURORA, ILL., June 7.—Officer Drake detected a man in the act of picking the pocket of a lady standing in the crowd watching the circus procession pass, yesterday morning, and at once arrested him and locked him up. The man gave his name as George Murray.

PICK-POCKETS.

[Special Telegram.]

AURORA, ILL., June 7.—A pack of pick-pockets came here to-day. Detective Atkinson, with Cooper & Bailey's Circus Company, nabbed two light-fingered fellows, and our own police as many more,

amount of money; how much is not known. Nelson Cards lost ten or fifteen dollars. The house of Mrs. Cooper, of West Ottawa, was entered, where they got seven or eight dollars. The number of persons who lost watches and pocket books is hard to tell. At least a dozen have been heard of.

COOPER & BAILEY'S

Great International

Ten Allied Shows

Visited Ottawa and Aurora on the dates as referred to in The Chicago Times. Thus again is the old adage verified that the actual thief is the first and loudest to shout

THIEF! THIEF! THIEF!

LOUD-MOUTHED THIEF SHOUTERS

Citizens of Mankato, take the advice of one one who knows of what he speaks, and keep your hands on your pocket books, watches and jewelry, and don't trust your stores or private residences to what you may consider good and safe locks, but keep a sharp watch over any property you may possess until you are sure the

are at least thirty thirty miles away from your homes. The same lawless gang THAT VISITED OTTAWA and AURORA, [of which The Chicago Times warns you,] Propose Paying their Respects to Mankato

ON THURSDAY, JUNE 29th,

WITH THE

COOPER & BAILEY

SELF-STYLED

Great Moral International Circus!

When a circus company finds it actually necessary and compulsory on their part to employ a private detective force to watch their own employees, our city and town authorities should be on the alert and beware how they permit such a cloaked gang of three-card-monte, desperadoes, thieves, house-breakers and villians to enter their town and be turned loose to raid on the homes of defenseless citizens. Our town authorities should take warning from The Chicago Times and numerous other newspapers, and have our police in full force, and inform themselves of the character of the self-styled detectives, acting for and under orders of the circus company, and have our town police keep a strict watch over every movement of said traveling detective force, for they are really more to be feared than the most skillful pick-pocket.

Once More--Keep a sharp watch over every movement of the Traveling Detectives.

On Thursday, June 29th!

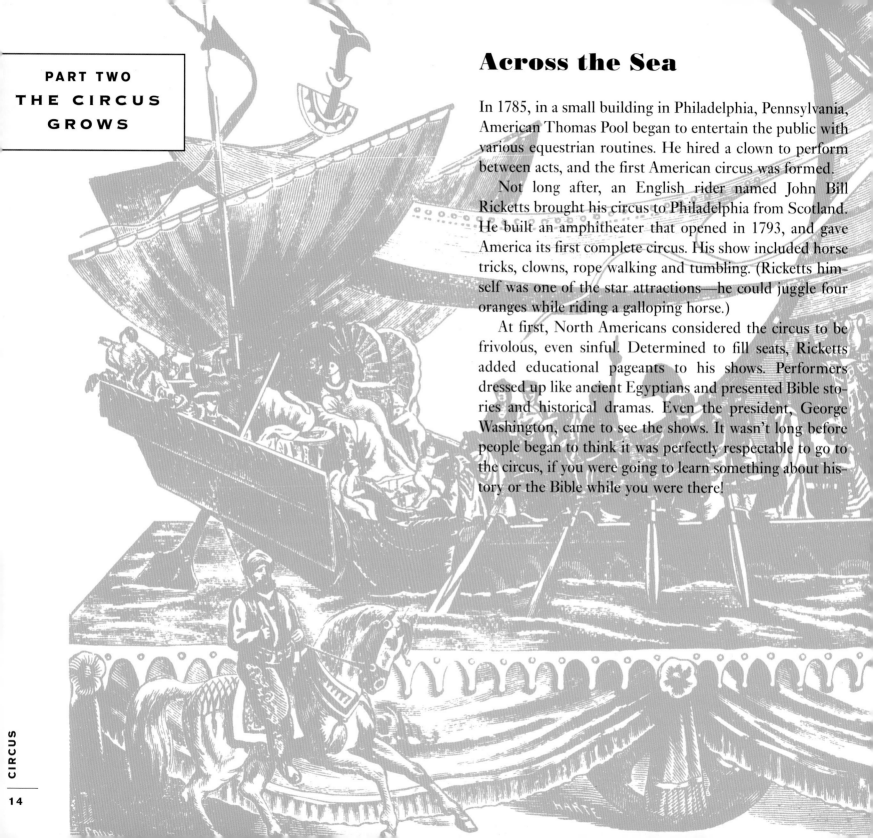

Across the Sea

In 1785, in a small building in Philadelphia, Pennsylvania, American Thomas Pool began to entertain the public with various equestrian routines. He hired a clown to perform between acts, and the first American circus was formed.

Not long after, an English rider named John Bill Ricketts brought his circus to Philadelphia from Scotland. He built an amphitheater that opened in 1793, and gave America its first complete circus. His show included horse tricks, clowns, rope walking and tumbling. (Ricketts himself was one of the star attractions—he could juggle four oranges while riding a galloping horse.)

At first, North Americans considered the circus to be frivolous, even sinful. Determined to fill seats, Ricketts added educational pageants to his shows. Performers dressed up like ancient Egyptians and presented Bible stories and historical dramas. Even the president, George Washington, came to see the shows. It wasn't long before people began to think it was perfectly respectable to go to the circus, if you were going to learn something about history or the Bible while you were there!

John Bill Ricketts grandly called his building in Philadelphia the Pantheon. He went on to open circuses in other eastern cities, but his luck turned when a number of his buildings burned to the ground. Eventually Ricketts decided to return to England to make a fresh start. However, he didn't leave his bad luck behind—the ship he traveled on was lost at sea.

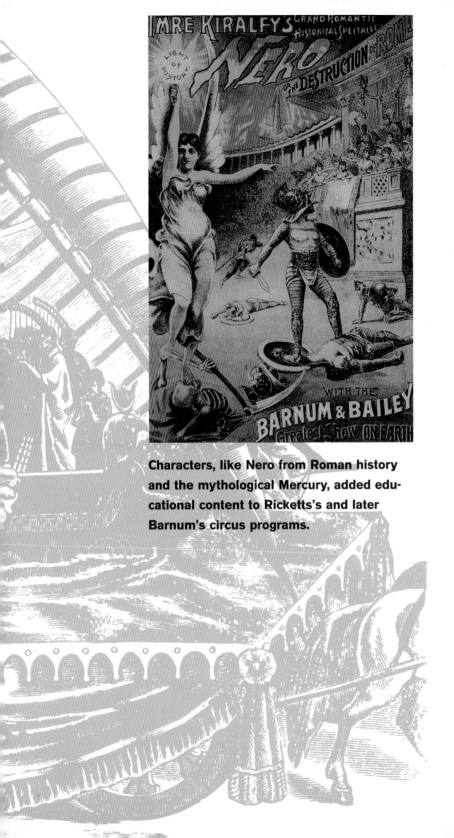

Characters, like Nero from Roman history and the mythological Mercury, added educational content to Ricketts's and later Barnum's circus programs.

Ricketts' Circus.

THIS DAY, the 15th of May, At the Circus in Market, the Corner of Twelfth streets. The Doors will be Opened at 4, and the Performance begin at half past Five o'clock, precisely

Will be Performed—*A Great Variety of* **Equestrian Exercises,**

By Mr. & Master *Ricketts*, Master *Strobach*, and Mr. *M'Donald*, who is just arrived from Europe.

In the Course of the Entertainment, Mr. Ricketts will introduce several *New Feats*, particularly he will Ride with his Knees on the Saddle, the Horse in full speed; and from this Position *Leap over a Ribband* extended 12 feet high.

Mr. Ricketts, on a single Horse, will throw up 4 Oranges, playing with them in the Air, the Horse in full speed.

Mr. *M'Donald* will Perform several COMIC FEATS (Being his First Appearance in America).

Seignior *Spiracuta* will exhibit many Surprizing Feats on the Tight Rope.

The whole to conclude with Mr. Ricketts and his Pupil in the Attitudes of two Flying Mercuries; the Boy pois'd on one Foot on Mr Ricketts' Shoulder, whilst Mr. Ricketts stands in the same Manner with one Foot on the Saddle, the Horse being in full speed.

⁎⁎⁎ Those Ladies and Gentlemen who wish to embrace the present Opportunity of seeing the Exercises of the Circus, are respectfully informed, that Mr. *Ricketts* intends closing it for the Season within three Weeks from the present Time, as he is about to take a Tour to some other Parts of the Continet

Tickets sold at Mr Bradford's Book Store, Front street, and at the Circus.

Box 7/6—Pit 3/9.

Wanted Immediately.

The Camels Are Coming

During the eighteenth century, merchants sent their ships to all corners of the earth. Sometimes, along with their regular cargo, crews would bring back unusual plants and animals from exotic places. People were all too willing to pay to see such never-seen-before items. (Often they were astonished to discover that animals such as camels and giraffes were considerably larger than illustrations had led them to believe!) Circus owners quickly added traveling displays of exotic animals to their shows and, by the 1830s, these menageries had become a standard feature of many circuses.

It's hard to imagine how excited people were about these "new" animals because most of us have seen them in zoos, books and movies and on television. But what would happen if scientists announced that they had captured the real Abominable Snowman, and that the creature would be displayed "for a limited time only"? Would you line up?

THE Elephant,

ACCORDING to the account of the celebrated BUFFON, is the moſt reſpectable Animal in the world. In ſize he ſurpaſſes all other terreſtrial creatures; and by his intelligence, he makes as near an approach to man, as matter can approach ſpirit. A ſufficient proof that there is not too much ſaid of the knowledge of this animal is, that the Proprietor having been abſent for ten weeks, the moment he arrived at the door of his apartment, and ſpoke to the keeper, the animal's knowledge was beyond any doubt confirmed by the cries he uttered forth, till his Friend came within reach of his trunk, with which he careſſed him, to the aſtoniſhment of all thoſe who ſaw him. This moſt curious and ſurpriſing animal is juſt arrived in this town, from Philadelphia, where he will ſtay but a few weeks.————————— He is only four years old, and weighs about 3000 weight, but will not have come to his full growth till he ſhall be between 30 and 40 years old. He meaſures from the end of his trunk to the tip of his tail 15 feet 8 inches, round the body 10 feet 6 inches, round his head 7 feet 2 inches, round his leg, above the knee, 3 feet 3 inches, round his ankle 2 feet 2 inches. He eats 130 weight a day, and drinks all kinds of ſpiritous liquors; ſome days he has drank 30 bottles of porter, drawing the corks with his trunk. He is ſo tame that he travels looſe, and has never attempted to hurt any one. He appeared on the ſtage, at the New Theatre in Philadelphia, to the great ſatisfaction of a reſpectable audience.

A reſpectable and convenient place is fitted up at Mr. VALENTINE's, head of the Market, for the reception of thoſe ladies and gentlemen who may be pleaſed to view the greateſt natural curioſity ever preſented to the curious, and is to be ſeen from ſun-riſe, 'till ſun-down, every Day in the Week, Sundays excepted.

☞ The Elephant having deſtroyed many papers of conſequence, it is recommended to viſitors not to come near him with ſuch papers.

☞ Admittance, ONE QUARTER OF A DOLLAR.——Children, NINE PENCE.

Boſton, Auguſt 18th, 1797.

BOSTON: Printed by D. Bowen, at the COLUMBIAN MUSEUM Preſs, head of the Mall.

Visitors were astounded by the vast number of menagerie animals that they had never seen before. Equally amazing was the fact that the elephant who visited America in 1797 drank thirty bottles of beer per day and yet "he travels loose."

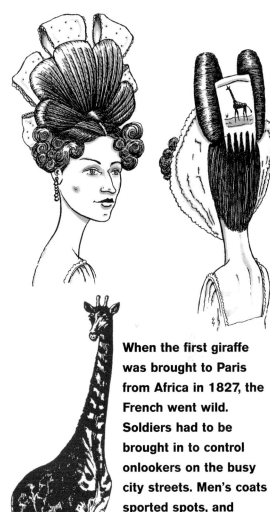

When the first giraffe was brought to Paris from Africa in 1827, the French went wild. Soldiers had to be brought in to control onlookers on the busy city streets. Men's coats sported spots, and women began to wear their hair in a "giraffe" style. Thankfully, the craze was short-lived, lasting a bit longer than a year.

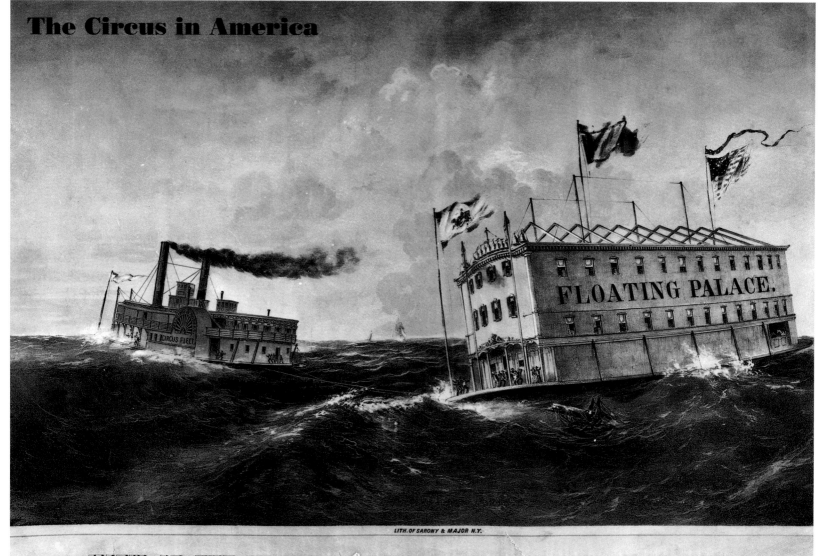

LITH. OF SARONY & MAJOR N.Y.

VIEW OF THE FLOATING PALACE IN THE GULF OF MEXICO,
IN HER PASSAGE FROM MOBILE TO THE BALISE
IN THE MEMORABLE STORM OF THE 28TH OF JANUARY 1853 IN WHICH THE GUARDS OF HER CONSORT THE NORTH RIVER WHICH HAD HER IN TOW, WERE CUT AWAY TO ESCAPE SHIPWRECK.

In Europe, Philip Astley, Charles Hughes and Antonio Franconi all constructed their own buildings where audiences were protected from the elements. They also set up business in major cities, where a large population assured them of steady audiences. In America, however, even the larger cities had small populations, which made the construction of per-manent circus buildings a poor investment. So circus owners took their shows on the road.

Early nineteenth-century roads were dusty, rutted affairs. Performers and their gear had to be loaded into horse-drawn wagons that took to the highways for months on end. These wagon trains sometimes included as many as one hundred vehicles.

After heavy rains, the wheels often sank into the thick mud right up to the hub, and it took many men to push the wagons out of the mire. (It's no surprise that the horse-pulled circuses came to be called "mud shows"!) Such operations performed only one night in each community. After the show, everything had to be packed up and moved a few miles down the road to the next town for another one-night visit. The muddy wagons were washed just outside of town, since first impressions were important.

Some circuses traveled on a watery road. "Boat shows" were presented on flatboats or steam-driven paddlewheelers that traveled the Ohio and Mississippi Rivers and the Great Lakes in the early 1800s. One river-bound circus, the Floating Palace, could seat 2,400 people around its ring. The performers lived on a tugboat that towed the Palace, and a second tow boat carried a menagerie. On board, the audience could enjoy clowns, gymnasts, pantomime and trick horse riding.

By the 1870s, circuses began to travel into the countryside by train. In 1872, W.C. Coup and P.T. Barnum's Greatest Show on Earth became the first circus to be moved entirely by train. In 1994, the Ringling Bros. and Barnum & Bailey Circus logged more than 25,000 miles in two 48-car private trains, each nearly a mile long!

Up to the wheel hubs in thick mud, this wagon filled with ring curbs and platforms is delayed.

While tents and rented arenas have been the traditional homes of North American circuses, elsewhere in the world more permanent lodgings have been built. The circus in Europe has performed in buildings rich with painted murals, gilded woodwork, stained glass and velvet seats, and it continues to do so. The Cirque d'Hiver (formerly the Cirque Napoléon) in Paris is the oldest permanent circus building. It opened in December 1852.

In Russia, so many people have made circus visits a part of their lives that more than seventy circus buildings have been constructed through the years, some with the most up-to-date hydraulic equipment and theatrical lighting.

In North America, a number of circuses are attempting to give their shows more permanent homes, too. Cirque du Soleil has announced plans for a building in Montreal, Canada, and the organization already has a home for one of its shows in Las Vegas, Nevada.

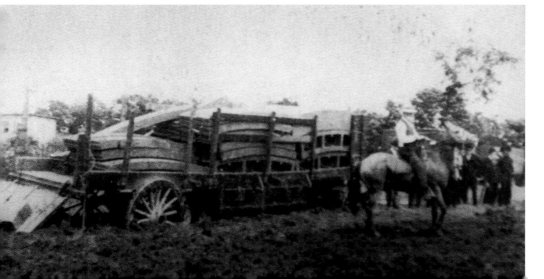

Renz, Althoff, Hagenbeck, Williams, Schumann and Busch. The history of the circus in Germany is filled with references to these directors, founders and their thriving families that have carried on their circus traditions, both at home and abroad. German circuses have taken their acts as far as Japan, showing off animals, like giraffes, that audiences have never seen before. And changes came to the German circus itself when Barnum & Bailey toured Europe in 1900. When circus head Carl Krone saw the three-ring extravaganza, he went on to create an even larger, more colossal version, complete with eight hundred animals and three rings instead of the usual European single ring. After World War II, Circus Krone went back to one ring, but it remains the largest circus in Europe, with its base in a permanent building that was opened in Munich in 1962.

One of the most popular German shows is Circus Roncalli, founded by Bernard Paul in the 1970s. As a boy, Paul saw his father trudge off to his factory job while circus workers relaxed outside their wagons. Soon everything about the circus enticed him. He invented his own acts, juggling with paper plates. He did odd jobs for visiting circuses in exchange for tickets.

Bernard Paul turned his childhood fascination into a career. He bought a used circus wagon and began to put on shows with a couple of friends and a family of performers. With Circus Roncalli, he wanted to re-create the magic of an old-fashioned street circus. There are no ringmasters, no life-threatening acts—just plenty of fun with pantomime, fire-eating, and magical lighting and music.

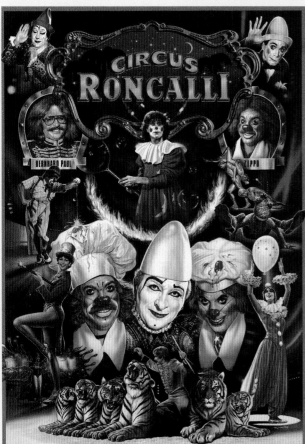

The Program of Displays for many circuses is sure to include performers from Asia, where incredible circus skills have been passed down for centuries. Some of the first clowns known to historians were active in the court of the Chinese emperor 4,000 years ago. Clowns also entertained long ago in Burma, Bali and Malaysia.

Acrobatic skills have long been the specialty of Asian troupes. Parisians were entertained by Japanese acrobats in 1866, and performers like the Fu Hsing acrobatic troupe and members of the Great Circus of China have continued to tantalize circus audiences around the world.

Hand balancing (page 68) is an ancient art well represented by Asian performers. Needing no more equipment than two skilled people, the performers shift from one position to another, never shaking, always smiling. Often, such acts have been honed over many generations of one Asian family.

Other popular balancing acts with long histories include combinations of body-contorting positions and the movement of bowls and cups from one part of the body to another.

Young children, while perched on a unicycle, flip bowls from their feet to a growing stack on top of their heads!

Two performers stand still—and suddenly five others are lifted into the air and held aloft for endless seconds!

Bicycles circle the ring and more and more riders jump on until it looks as if the bicycle will collapse. Yet still it moves around and around, heavy with smiling, perfectly balanced youngsters!

And then there's the phenomenal horseback riding from Mongolia (page 63).

Today, Asian circus performers travel the world, and the world's circuses are increasingly performing in Asia. In 1996, 50,000 tickets were sold when Canada's Cirque du Soleil took its theatrical show to Hong Kong. Some people were surprised at the success of the visit because even traditional circuses, complete with Big Tops and animal acts, had scarcely appeared in the city in decades. Like other parts of the world, Asia is experiencing a renewed interest in the magic of the circus.

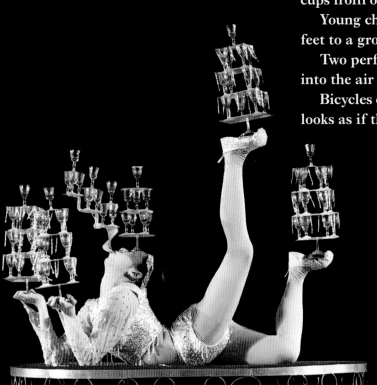

P.T. Barnum and
the Greatest Show on Earth

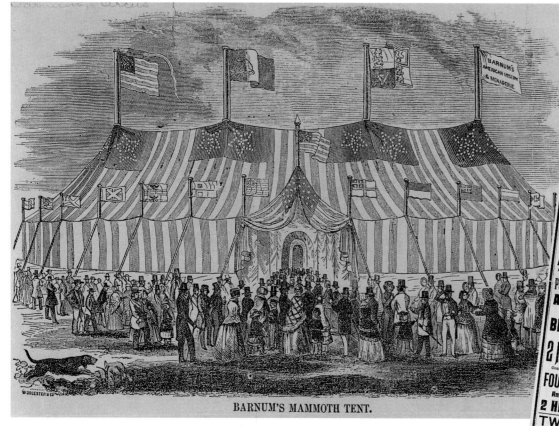

BARNUM'S MAMMOTH TENT.

Elegantly dressed families enjoyed Barnum's shows in a huge canvas tent decorated with colorful flags and buntings.

Barnum's lively advertisements, filled with words like "immense," "colossal" and "mammoth," convinced readers that bigger was best!

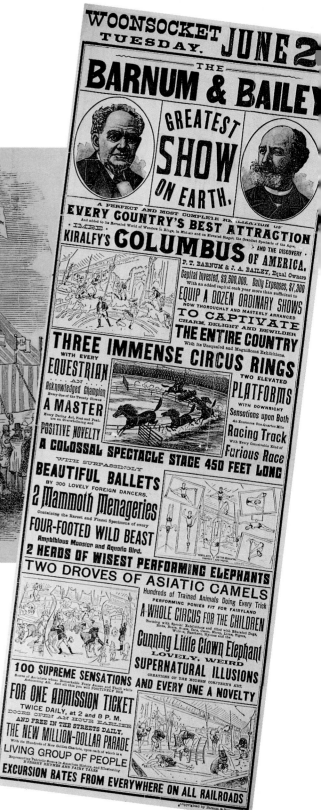

Phineas Taylor Barnum (1810-1891) was a businessman with a knack for finding out what interested people, and then getting it for them. One day he heard about a slave named Joice Heth, who was reported to be 161 years old and had once been the nursemaid of George Washington.

Barnum sold his grocery business, "bought" Joice Heth and filled newspapers with advertisements about the "ancient" woman. Posters were pasted up all over New York, and customers came, and paid, to watch Joice Heth sing songs, chat with the audience and smoke her pipe. When Barnum's first star died a few months later, the doctors pronounced her to be no more than eighty years old. Barnum said he was astounded to learn the truth. He said he'd been fooled as much as the public. And he saw that the public enjoyed being fooled.

Barnum went on to buy the American Museum in New York City. For twenty-five cents, customers could see three floors of curiosities that he had collected, live shows by knife throwers and magicians, and the Feejee Mermaid. No matter that the mermaid was really a dried monkey's head and torso attached to the lower half of a huge fish! People were fascinated and kept coming back for more.

During his career, Barnum intro-

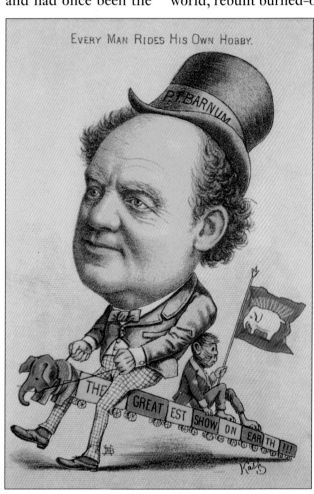

EVERY MAN RIDES HIS OWN HOBBY.

Many people believe that P.T. Barnum said, "There's a sucker born every minute," but he didn't. More in keeping with his flare for business is the quote, "As long as there are children, there will always be a circus."

duced North America to Swedish singing sensation Jenny Lind. He brought Jumbo the elephant to America, took the giantess Anna Swan and the midget Tom Thumb around the world, rebuilt burned-out museums, declared bankruptcy, and became the world's most famous showman.

At the age of fifty-eight, Barnum went into politics, but he didn't stay away from show business for long. In 1871, he and his partners opened a tent circus called "Barnum's Great Traveling Museum, Menagerie, Caravan, Hippodrome & Circus," and his career as a circus owner began.

Barnum's partner, W.C. Coup, invented a ramp that allowed circus wagons to be pulled onto railroad cars. This meant the show could speedily travel overnight to the next day's site. Clever advertising warned, "Wait for Barnum. Don't Spend Your Money on Inferior Shows." And it worked. Hundreds of performers and animals, including barking sea lions, entertained crowds in large arenas like the new Madison Square Garden in New York. Barnum presented a tattooed lady and Mademoiselle Zazel, the first human cannonball.

Eventually Barnum joined forces with a competitor, James A. Bailey, and they advertised their new circus as "The Greatest Show on Earth."

Each day at the Barnum & Bailey Circus began with a
thirteen-cannon salute and ended with fireworks. During the
hours in between, Barnum's 4,000 employees, performers and
animals used 32 tons of sawdust at every site, spread under
32 acres of canvas tenting.

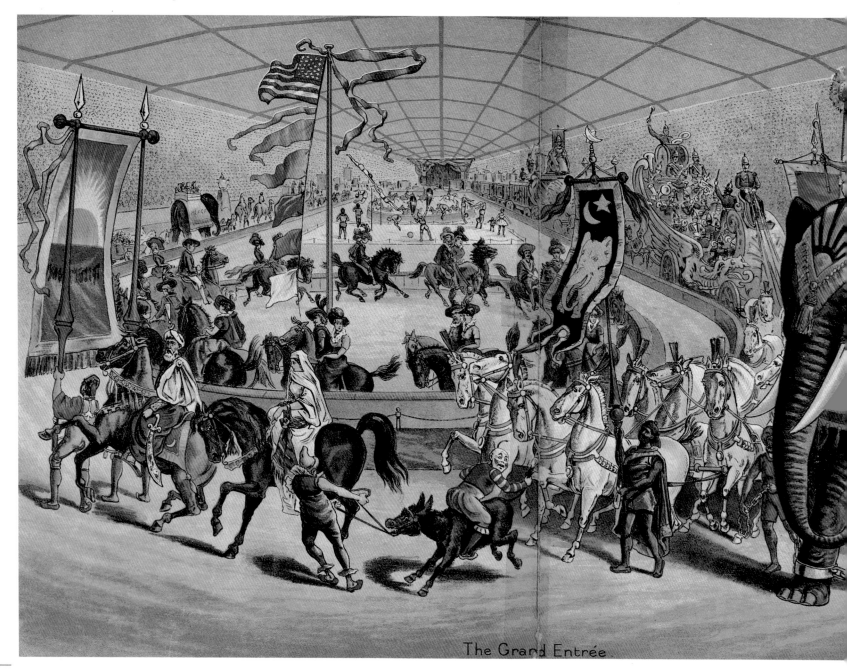

The Grand Entrée

Switzerland's Circus

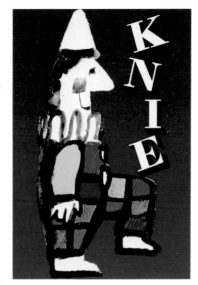

This 1956 poster by Herbert Leupin puns on the famous name, which means "knee."

Friedrich Knie left the medical profession to join a circus in 1803. By 1818, he had founded his own troupe, had traveled through Austria and Bavaria, and was finally in Switzerland. The Circus Knie was famous for its tightrope acts in the open air. The circus grew to include animal acts, too.

The Knie family continued to develop its circus over the generations, each in turn refining the show. By 1919, the Knies' circus became known as the National Swiss Circus, and Knie brothers financed the first tent by selling postcards to the public. The tented show opened in Bern. Bigger tents followed until the Circus Knie was seating 5,000 spectators per show. The success story continues to this day, as yet another generation is born, and the family develops new shows. The Circus Knie, like other European circuses, visits the same cities on the same dates each year; the family knows that exciting, new material will keep the seats filled year after year.

The Knies join the other great families, Nock, Bauer, Grock, Stey and Gasser, in linking the Swiss circus past to the present through business and marriage.

Italy's Circo

Traveling entertainers have long roamed the hills of Italy, the land of *commedia dell'arte*. The Chiarinis were just one family who entertained in Italy as far back as the 1500s. The traveling troupe presented puppet shows and tightrope walking. Trick riding was added later. By 1975 there were more than 140 large and small Italian circuses, many of them carrying on a family tradition.

The Togni and Orfei families have been in the Italian circus business for more than a century. Circo Nazionale, Circo Massimo and Circo Italiano have been operated by Togni family members through the years. They entertained Italian audiences with superb menageries and aerial acts; they also brought to the country foreign circuses like the Circo Nacional de Mexico.

The Orfeis became known for their luxurious tents, plush seating, and as many as sixty clowns in sparkling costumes. Some family members became movie stars, quickly recognized by an adoring public. In fact, a film screen was incorporated into their circus. During the "spec," the audience could watch movies of, for example, Mount Etna erupting, while posing acrobats passed in front of the screen.

"Circorama" in Milan, a combination of cinema and circus, was yet another of the Orfei family's original presentations. The Orfeis also gave Italy its first circus on ice!

The Ringling Brothers

When German harness maker August Rungeling moved to the United States he, like many new immigrants, wanted to change his name to something that sounded "more American." And so Rungeling became Ringling. August married a French woman and settled down to raise a large family in Iowa. There, along the banks of the mighty Mississippi River, the seven Ringling sons and one daughter fell in love with the circus boat shows. The boys invented their own circus acts using the family's goats, and it's said that their mother dyed their old long underwear red to serve as acrobatic tights.

Bad economic times in the 1870s meant less work for August. He moved his harness business and his family to Baraboo, Wisconsin, where the oldest son got a job as a tightrope walker in a traveling show. Later he urged four of his brothers to join him and start a Ringling show in 1882.

There was plenty of music, comedy and juggling in the Ringling Brothers Classic & Comic Concert Company. The five brothers painted old farm wagons and added a pig that could do tricks.

No matter how good their circus was, however, the Ringling brothers had to deal with the common opinion that all circuses were filled with thieves who stole the wash off clotheslines and helped themselves to a family's possessions while the townspeople lined the main street to watch the grand parade. People were sure that pickpockets worked the crowds at shows, and that employees shortchanged customers. Some of these beliefs were based on fact, but not every circus was a home for criminals.

The Ringlings laid down rules for their employees. No cheating. Workers must be polite to customers at all times. Especially demanding rules were in force for the young women performers, for both their protection and the show's reputation: "Be neat and modest in appearance," "You are not permitted to talk or visit with male members of the Show

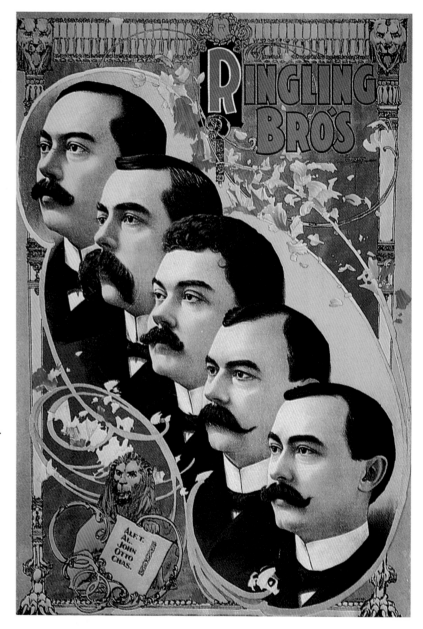

The fun-loving and creative spirit of the five dapper Ringling brothers is hidden in this serious portrait of the circus impresarios.

Company, excepting the management," "Girls must not stop at hotels at any time." Detectives were hired to stroll around the circus grounds and watch for thieves.

Other circus operators called the Ringling operation a "Sunday school show," but ticket buyers proved that the Ringlings were right. People wanted to see the circus, but they didn't want to be robbed. By the 1890s, all seven brothers were involved in the circus.

For a while the Ringling show played for midwest towns, while Barnum's traveled in the eastern United States. But by 1895, Ringling shows had moved into New England. Their parade stretched for three miles, and it boasted forty elephants and a huge calliope (page 33) at the end of it all. The Ringlings bought the Barnum & Bailey circus in 1907 and ran the two shows separately for a while. Then, in 1918, the two circuses were united into the "Big One," with tent room for 10,000 spectators, and 2,500 performers and animals moving from town to town by train.

The Greatest Show on Earth has grown with the times, even developing the computer software SimCircus, so fans can interact with the ringmaster, acrobats and animal trainers.

A portrait of John Ringling and his wife Mable decorates a ceiling of their beautiful home, Ca'd'Zan ("the house of John"), completed in 1926 in Sarasota, Florida.

Russia's Tsirk

After Charles Hughes left Russia in 1793, the circus continued to grow there. Troupes of masked actors, called *skomorokhi*, wandered the countryside and entertained the villagers. Trained bear acts were included in many of these shows, and they are still a part of the Russian circus.

Meanwhile, in the city of St. Petersburg, foreigners like Hughes and Gaetano Ciniselli produced shows for the upper class. Their buildings had comfortable chairs for the rich and wooden chairs set high in the galleries for those who weren't. Equestrian acts were particularly popular.

Soon Russian-born directors were producing full-scale circuses, and buildings were constructed in Moscow, Riga, Odessa and Kiev. Performers like the Durov brothers (page 66) daringly added political comedy to the shows, and clever, creative clowning would continue to be a Russian tradition.

After the October Revolution in 1917, Russian leader Vladimir Ilyich Lenin signed an historic decree that nationalized the circus. However, a government-supported circus likewise had to support the government, and propaganda entered the ring. In 1926, the Moscow Circus School opened—the first

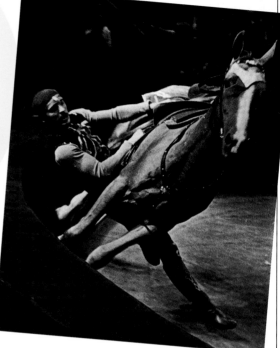

The speed and danger of the *djigit* rider's act makes it a breathtaking highlight of the Russian circus.

school for circus performers in the world.

By the 1980s there were 127 circuses in Russia. They employed about 8,000 people and performed in more than sixty cities every night. Circus performers were among Russia's most respected citizens. When the Moscow Circus began to tour the world, it became renowned for its animal acts and its daring, exciting acrobatic feats.

The French Cirque

Thanks to Philip Astley, the circus has been thriving in France for more than 150 years. Traveling circuses with their *saltimbanques* (acrobats) took the excitement into the countryside. And in the cities, circus dynasties founded by people like Theodore Rancy and the Franconis dazzled audiences with grand pantomimes and equestrian acts, including "La Fille de l'Air," where Mademoiselle Franconi, lightly gowned in a goddess costume, balanced atop a prancing pony. Enormous hippodromes were built, some holding as many as 8,000 circus fans.

Then, around 1900, huge traveling circuses and menageries, like those of P.T. Barnum and Frank Bostock, visited France and introduced European audiences to grand multi-ring spectacles. Bigger seemed to mean better.

By the beginning of the early twentieth century, Paris had become the world circus capital. There was the visiting Circus Sarrasani, called the most beautiful circus, with its single ring, "tempest of acrobats" and carefully choreographed acts. And the Circus Medrano, with its director-clown "Boum-Boum," was famous for its talented clowns like Porto and Chocolat. The historic Medrano building in Paris was torn down in 1974, but that same year, Alexis Gruss, a member of a distinguished circus family, created Cirque Gruss in the capital.

Since the 1970s, the French circus has experienced renewed life. The Paris equestrian circus and theater troupe Zingaro, the Volière Dromesko (a bird circus) and the Cirque Archaos (with motorized vehicles) have provided new interpretations of circus arts, and they are filling seats with a new generation of circus fans. Statistics for the 1990s are staggering. In one year, nearly 10 million French fans attended the circus.

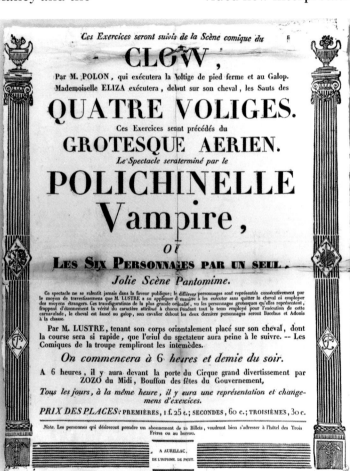

This early French circus advertisement promises horseback riders and a pantomime performance. It also claims that Monsieur Lustre will travel so rapidly around the ring that the audience's eyes will have difficulty following him!

Footitt and Chocolat are two of the most famous clowns in French circus history.

Spreading the News

Today, a circus advertises or "ballyhoos" its visit to a particular city with newspaper ads, radio and television spots, even notices on the Internet. Members of the circus are interviewed on local talk shows, and camera crews visit the circus site to film practice sessions. Press releases, photographs and videotapes of circus performers are mailed to the media and then carefully followed up by publicity folks specifically hired to promote the circus.

In the old days, before all this electronic media, circus owners had to use other methods to spread the news of the circus's arrival. The circus's visit was often the entertainment highlight of the year. An "advance man" arrived about two weeks ahead of the circus to "sheet up" the town, or paste up posters announcing the show. Many a farmer got up in the morning to find that a huge circus poster had been glued onto his barn overnight.

Circuses often glued their posters right on top of their competitors'. Rat sheets were pasted up, too. Advance men could get carried away with their job, and the resulting wallpapering of a town was known as "poster nuisance." Large circuses like Barnum and Ringling reportedly put up more than five thousand posters per town!

In the late nineteenth century, the circus poster flourished in Europe. Artists like Jules Cheret and the Levy Brothers in France, and Adolph Friedlander in Germany, attracted customers with thousands of designs showing incredible feats.

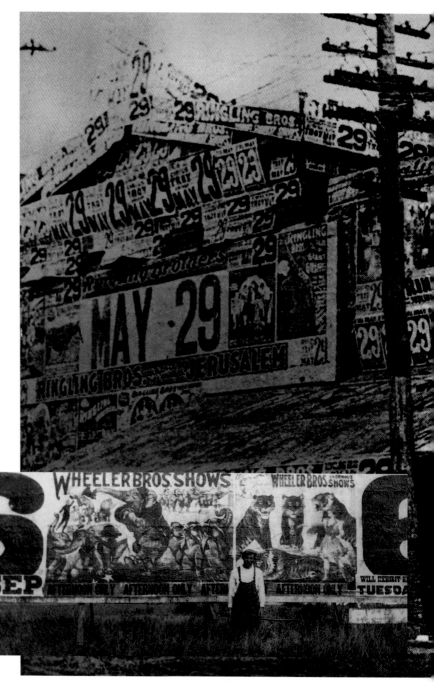

Circus posters were pasted up on any available surface.

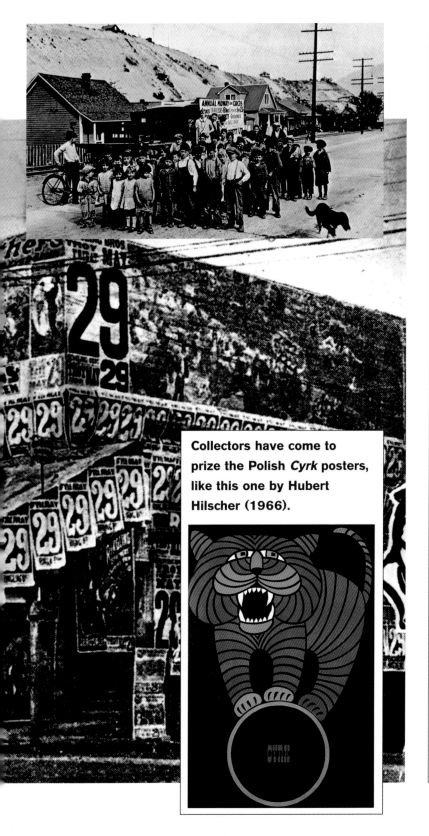

Collectors have come to prize the Polish *Cyrk* posters, like this one by Hubert Hilscher (1966).

Andrew King (1885-1981)

It was quite by accident that a young Canadian named Andrew King became one of the leading circus poster printers in the world. One day, a circus advance man walked into King's newspaper and printing office in Saskatchewan. He hadn't received his poster supply and needed more printed as quickly as possible. Could King help?

King completed the job, the advance man went away happy, and Enterprise Show Print (later King Show Print) was born. One of King's best customers in the circus was Clyde Beatty (page 67).

Andrew King designed and hand-cut large wooden blocks to create the window placards and enormous circus posters, as

well as artwork for carnivals, fairs and sports events. The printing process called for precision. The images were made by applying one color of ink to one block and then printing it on the paper. Then a second color on a second block was applied to the paper. More colors, each on a separate hand-cut block, were printed in layers as needed. A slight shift of paper or block resulted in a ruined print.

Assisted by his family, Andrew King created images like the tiger leaping through a paper-covered hoop—pictures that still mean "circus" to many around the world.

Here Comes the Parade

If the advance men had done their job, employers would close their shops on Main Street and customers would jostle at the edge of the wooden sidewalk to watch the gala circus parade go by. There was no better advertisement for the circus's visit to town than the parade itself.

Bandwagons that could seat an eighteen-piece band were so huge that forty horses were needed to pull them. There were brightly painted animal-cage wagons, horses, chariots, camels and huge elephants sporting jeweled blankets. Tableau wagons featured scenes with live characters. Alongside the parade, clowns cartwheeled down the dusty, unpaved streets. The circus owner relied on the spectacular parade to lead the citizens back to the circus lot to buy tickets for the show.

The parade wagons themselves were works of art. The sides often had intricately carved and painted panels finished in gold leaf that gleamed in the sunshine or lamplight, in the days before electric lights. The wagon wheels, some five feet in diameter, would make swirls of color as they rolled down the parade route.

During what is called the Golden Age of the Circus (1880-1910), the gala parades flourished. But gradually these huge parades disappeared. Some people thought they'd seen everything the circus had to offer once they'd watched the free parade. The increasing number of automobiles on paved streets clogged the parade route and made it dangerous. As the Great Depression approached, people also had less money to spend, and the circus companies had to cut costs in order to keep operating. Eventually, some of the gorgeous parade wagons were left in fields to rot.

The circus parade, however, is not gone forever. Today,

Those Glamorous Girls

In the 1890s, a "proper" woman would not have gone out in public with her ankles and arms exposed to one and all. At the circus, however, the women aerialists, trick riders and dancers exposed much more, to the shock of people who already considered the circus a scandalous and immoral place.

While it is easy to see that the long skirts and full sleeves of the 1890s woman would have been dangerous in the ring, there's no doubt that the scantily dressed performers contributed to ticket sales. Men reportedly left the tent disappointed when Lady Godiva rode into the ring wearing a loose, flesh-colored bodysuit, rather than naked, as the legend portrays her!

Sometimes audiences debated whether the attractive performers, like Charmaine, were male or female.

The bandwagon noisily announces the circus has arrived. In 1915, an early model car pulls over to listen—and a boy bicycles alongside.

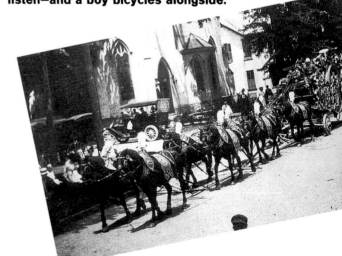

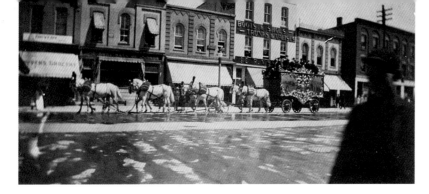

around the world, circus troupes often parade the elephants from the train to the circus site, and eager crowds line the short route. The grandest circus-wagon parade occurs every July in Milwaukee, Wisconsin. That's when the magnificent antique circus wagons, normally housed in the Circus World Museum in Baraboo, Wisconsin, parade through the city while circus buffs from around the world gather to celebrate the heyday of the circus wagon.

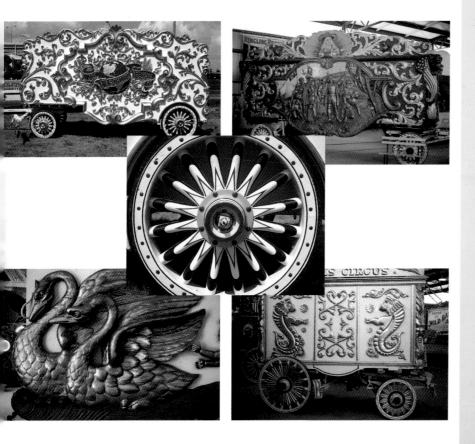

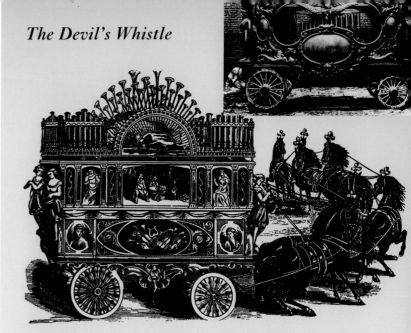

Loud, boisterous music was a big part of every circus parade. Trumpets and drums would play on the bandwagon up front. But the noisy "devil's whistle," or steam calliope, would close the parade at the end. The shrill notes were said to be heard ten miles away (they must have been deafening for the player who was so close to the pipes!).

The "kal-ee-ope" consisted of steam whistles played by a keyboard. When the player pressed the keys, the whistle valves opened and steam blew through them. The steam was produced by a coal-fueled boiler at the rear of the calliope wagon, which would shoot bits of coal into the air. It was difficult to produce true notes every time the keys were struck, because the steam pressure could vary. The calliope player had to have strong wrists to play against more than one hundred pounds of pressure.

When it was not being used as a musical instrument, the calliope was used to pump water to settle the dust in the ring and to cool down the canvas tents on hot afternoons. It also served as a mini fire truck.

THE CIRCUS IS COMING!

33

Under the Big Top

Circuses have been held in the open air ever since Roman times and some, like Germany's Circus Roncalli, continue to do so. But often the audience and the performers preferred to be protected from the sun and rain. Julius Caesar was said to have huge awnings stretched on ships' masts over his seats at the arena. In 1825, a circus was completely covered with canvas for the first time in North America; in 1840 the first small tent was raised in Britain.

Some circuses today are held in single Big-Top tents, like those used by Canada's Cirque du Soleil and a number of

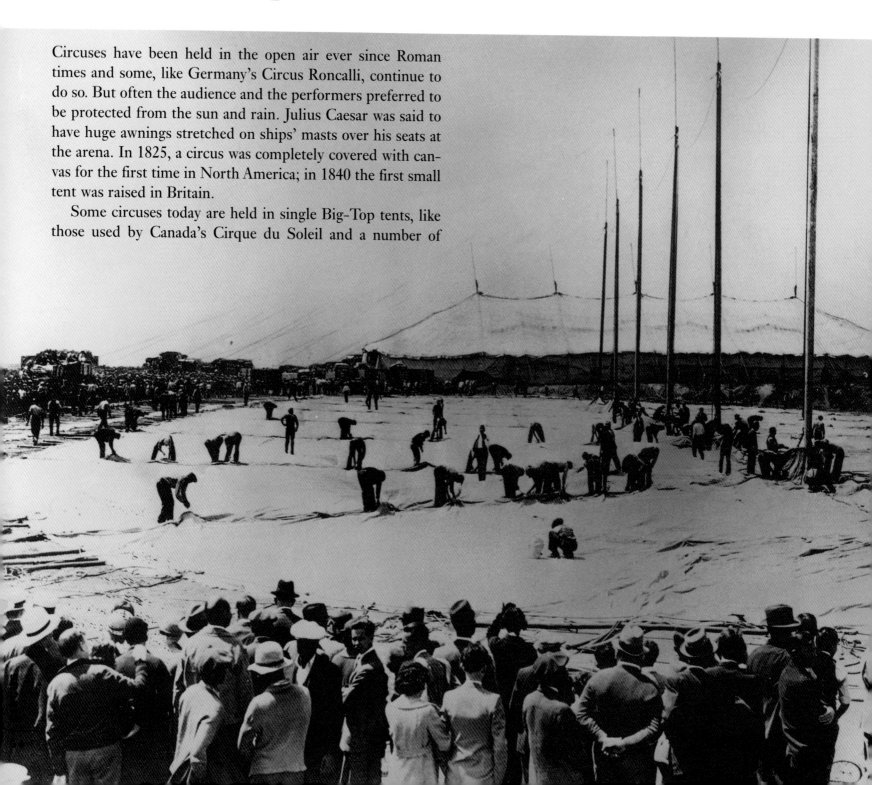

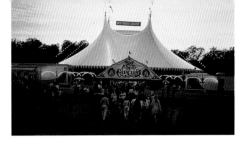

European and South American circuses. One hundred years ago, however, huge lots were needed to pitch the tents. It took as many as thirteen tents to hold the menagerie, the side shows, the performers, the souvenir and food booths. At times there was so much canvas that it covered land the size of a football field.

The tents were put up and taken down by roustabouts— the strongmen who built the Big Top. Sometimes the huge

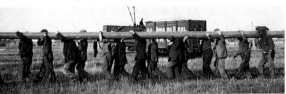

center poles were cut from timber near the site. Other troupes brought their poles with them, using elephants to help with transportation. Vast canvas tenting was spread out so the roustabouts could join together the different segments. Then the bottom edges of the tent were firmly attached to stakes. Finally, the threaded roof was raised by a bale ring around the center poles as the townspeople watched and cheered.

Putting up the Big Top took a great deal of time one hundred years ago, and even today, with the use of modern metal poles, towers, pulleys, cables and scaffolding, it can take many people to raise a large tent. However, exceptional organization makes things go as smoothly and quickly as possible. When people talk about a chaotic time as being "like a circus," they couldn't be farther from the truth. Huge tents can take as

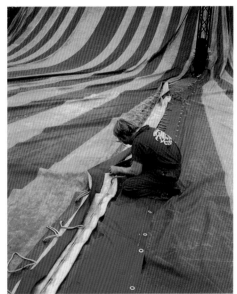

many as thirty hours to set up and fourteen hours to dismantle, and can accommodate nearly 2,500 spectators.

Many circuses now perform only in arenas, civic centers or stadiums. Special draperies gave the audience the impression that they are sitting in a much smaller, more intimate Big Top.

LOT LINGO

The circus community speaks a colorful language, or lingo, that draws on hundreds of years of circus history around the world.

Back yard: the area of the lot unseen by the public; location of animals, trailers, etc.

Blues: general admission seating, usually painted blue

Boss canvasman: the person in charge of putting up and taking down tents

Donniker: portable toilet

Front door: main entrance to the Big Top

Front end: everything the public sees before entering the Big Top

Hammer gang: the roustabouts who drive the stakes for the tent

Lot lice: an affectionate term for the townspeople who hang around circus lots

Shooting quarter poles: inserting the tent quarter poles into holes in the canvas and sliding them into postion to lift the peaks higher

Sidewall: canvas wall of a tent

Towner: local person who visits the circus

The Circus Family

The easiest way to join the circus is to be a member of the audience. For a few hours, anyone can be a part of the circus family. Many of the performers themselves, however, have been a part of the circus since they were born. Some learned circus skills before they could walk. Some have names that have been part of circus history for centuries: Knie, da Silva, Hagenbeck, Rancy, Price, Chipperfield. Because circus families have traditionally intermarried, techniques and skills are exchanged, and new performers are born. They may represent the ninth generation of their family to perform aerial tricks or acrobatics. Other performers may be newcomers who have trained at circus schools throughout the world before earning a place in a troupe.

The circus family travels, works and plays together. During a season, they'll probably cover thousands of miles. They spend their days living in close quarters and meeting few other people, since there is so little time to sightsee or go "into town." In fact, tradition maintains that circus people don't mix much with the "lot lice" when they are on the road.

The circus is like a small traveling village. Some circuses even appoint a "mayor" to keep things calm during the tour. Performers may have been hired from all around the globe, so interpreters are on site to help them understand one another.

But as in any large family that lives and travels together, there can be problems. Everybody knows everything about everyone else; it can be hard for performers to find privacy or time for themselves while touring.

Even the touring can be stressful. Some performers travel around the world for five years or more. Such a long time without a permanent home makes many performers long for a position with a circus that is rooted in one place.

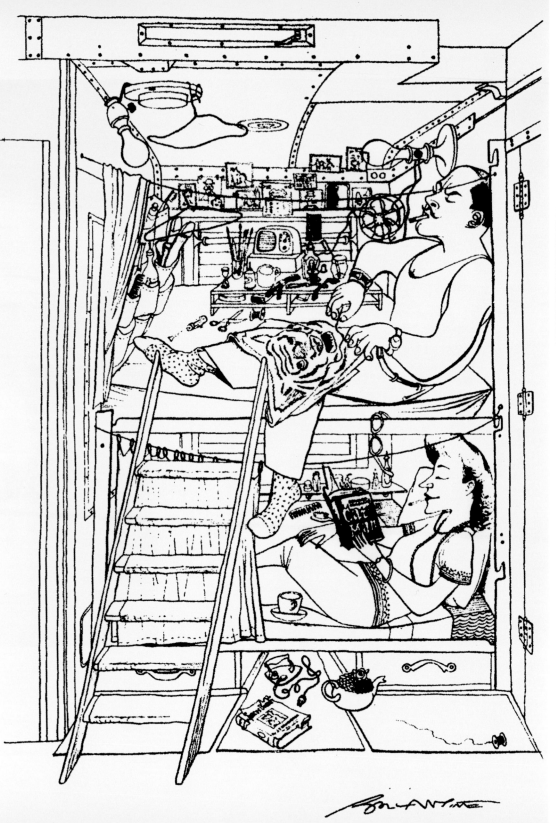

Extra workers are often hired when a circus arrives in town, and these roustabouts become temporary members of the family, observing the traditions, rules and superstitions (page 45) of the group. Some end up staying on and traveling with the company.

Artist Bill Ballantine captured the cramped living quarters of the Alzana and Bale families as they traveled with the Ringling Bros. and Barnum & Bailey Circus in the 1950s.

Home Away from Home

Long ago, performers lived in the wooden wagons that they drove from place to place while the circus was on tour. Living conditions were rough and crowded. When the circus traveled by train, each performer had a berth, with the most recently hired occupants in the cramped third bunks, their noses inches away from the ceiling. Ventilation was often poor, and performers had little privacy.

Conditions improved when circuses began to use trailers and recreational vehicles. Showers and bathrooms made life more comfortable. The family's television, video games and stuffed toys were within reach. Now when the circus arrives at the lot—perhaps outside a shopping mall or in a large parking lot or field—the RVs are parked around the edge of the area to make a mini village. Colorful canvas awnings are rolled down to shade the windows. Hanging pots of flowers suddenly dangle from the awning poles. Folding lawn chairs and tables, complete with tablecloths clamped down against the wind, create an instant patio. Children's wading pools and bikes lean against the side of the mobile home. Yet after a day or two, it will be time to pack everything up and move on again.

Sometimes the stars and managers of a show live in local hotels during the tour. Some performers like to drive their own cars ahead of the circus convoy and meet the troupe at the next destination. Most performers say it's a great way to see the world!

Whether they live in new trailer homes or in the tents of days gone by, circus families hang laundry, play and practice in their "backyard."

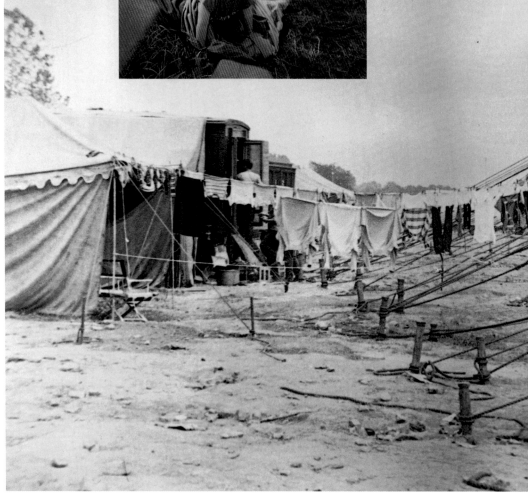

AL G. KELLY & MILLER BROS. CIRCUS

"AMERICA'S TENTED CIRCUS"

CIRCUS TOWN, U.S.A.

HUGO, OKLAHOMA

1959 OFFICIAL SEASON ROUTE

1st WEEK				
	Apr. 26	HUGO, (Mat. Only)	OKLA.	00
Sun.	Apr. 27	DURANT,	OKLA.	50
Mon.	Apr. 28	DENISON,	TEXAS	21
Tue.	Apr. 29	SHERMAN,	TEXAS	10
Wed.	Apr. 30	DENTON,	TEXAS	52
Thur.	May 1	ARDMORE,	OKLA.	63
Fri.	May 2	PAULS VALLEY,	OKLA.	45
Sat.				
2nd WEEK				
Sun.	May 3	PURCELL, (Mat only)	OKLA.	22
Mon.	May 4	CHICKASHA,	OKLA.	34
Tue.	May 5	EL RENO,	OKLA.	56
Wed.	May 6	NORMAN,	OKLA.	35
Thur.	May 7	SHAWNEE,	OKLA.	67
Fri.	May 8	GUTHRIE,	OKLA.	36
Sat.	May 9	STILLWATER,	OKLA.	
3rd WEEK				
Sun.	May 10	PAWNEE (Mat. only)	OKLA.	31
Mon.	May 11	CUSHING,	OKLA.	33
Tue.	May 12	SAPULPA,	OKLA.	71
Wed.	May 13	TAHLEQUAH,	OKLA.	60
Thur.	May 14	FAYETTEVILLE,	ARK.	11
Fri.	May 15	SPRINGDALE,	ARK.	10
Sat.	May 16	ROGERS,	ARK.	
4th WEEK				
Sun.	May 17	BENTONVILLE, (M.)	ARK.	10
Mon.	May 18	NEOSHO,	MO.	51
Tue.	May 19	MIAMI,	OKLA.	40
Wed.	May 20	PITTSBURG,	KAN.	48
Thur.	May 21	PARSONS,	KAN.	37
Fri.	May 22	INDEPENDENCE,	KAN.	31
Sat.	May 23	COFFEYVILLE,	KAN.	22
5th WEEK				
Sun.	May 24	SEDAN (Mat. only)	KAN.	36
Mon.	May 25	ARKANSAS CITY,	KAN.	50
Tue.	May 26	WELLINGTON,	KAN.	35
Wed.	May 27	WINFIELD,	KAN.	25
Thur.	May 28	EL DORADO,	KAN.	51
Fri.	May 29	NEWTON,	KAN.	31
Sat.	May 30	McPherson (Mem. day)	KAN.	
6th WEEK				
Sun.	May 31	LYONS, (Mat. only)	KAN.	32
Mon.	June 1	KINGMAN,	KAN.	37
Tue.	June 2	HUTCHINSON,	KAN.	52
Wed.	June 3	PRATT,	KAN.	63
Thur.	June 4	GREAT BEND,	KAN.	50
Fri.	June 5	HAYS,	KAN.	
Sat.	June 6	RUSSELL,	KAN.	
7th WEEK				
Sun.	June 7	Ellsworth (Mat. only)	KAN.	37
Mon.	June 8	SALINA,	KAN.	37
Tue.	June 9	JUNCTION CITY,	KAN.	50
Wed.	June 10	MANHATTAN,	KAN.	17
Thur.	June 11	TOPEKA (E. Side)	KAN.	51
Fri.	June 12	TOPEKA, (W. Side)	KAN.	10
Sat.	June 13	EMPORIA,	KAN.	53
8th WEEK				
Sun.	June 14	EUREKA (Mat. only)	KAN.	53
Mon.	June 15	CHANUTE,	KAN.	65
Tue.	June 16	IOLA,	KAN.	20
Wed.	June 17	FORT SCOTT,	KAN.	42
Thur.	June 18	NEVADA,	MO.	21
Fri.	June 19	BUTLER,	MO.	32
Sat.	June 20	PAOLA,	KAN.	61
9th WEEK				
Sun.	June 21	GARNETT, (Mat.)	KAN.	33
Mon.	June 22	OTTAWA,	KAN.	26
Tue.	June 23	OLATHE,	KAN.	41
Wed.	June 24	LAWRENCE,	KAN.	34
Thur.	June 25	LEAVENWORTH,	KAN.	39
Fri.	June 26	ATCHESON,	KAN.	26
Sat.	June 27	FALLS CITY,	NEBR.	61
10th WEEK				
Sun.	June 28	TARKIO, (Mat. only)	MO.	43
Mon.	June 29	MARYVILLE,	MO.	36
Tue.	June 30	CLARENDA (Mat.)	IOWA	37
Wed.	July 1	SHENANDOAH,	IOWA	23
Thur.	July 2	RED OAK,	IOWA	40
Fri.	July 3	ATLANTIC,	IOWA	35
Sat.	July 4	HARLAN,	IOWA	
11th WEEK				
Sun.	July 5	AUDUBON (Mat.)	IOWA	28
Mon.	July 6	CARROLL,	IOWA	27
Tue.	July 7	DENISON,	IOWA	26
Wed.	July 8	CHEROKEE,	IOWA	61
Thur.	July 9	LE MARS,	IOWA	36
Fri.	July 10	LUVERNE,	MINN.	51
Sat.	July 11	SIOUX FALLS,	SO. DAK.	
12th WEEK				
Sun.	July 12	SIOUX FALLS (Mat.)	SO. DAK.	00
Mon.	July 13	MITCHELL,	SO. DAK.	71
Tue.	July 14	HURON,	SO. DAK.	42
Wed.	July 15	REDFIELD,	SO. DAK.	44
Thur.	July 16	ABERDEEN,	SO. DAK.	61
Fri.	July 17	WEBSTER,	SO. DAK.	54
Sat.	July 18	WATERTOWN,	SO. DAK.	
13th WEEK				
Sun.	July 19	BROOKINGS (Mat.)	SO. DAK.	57
Mon.	July 20	MADISON,	SO. DAK.	45
Tue.	July 21	PIPESTONE,	MINN.	45
Wed.	July 22	MARSHALL, (Mat.)	MINN.	44
Thur.	July 23	MONTEVIDEO,	MINN.	79
Fri.	July 24	NEW ULM,	MINN.	47
Sat.	July 25	HUTCHINSON,	MINN.	

14th WEEK				
Sun.	July 26	LITCHFIELD (Mat.)	MINN.	24
Mon.	July 27	LITTLE FALLS	MINN.	71
Tue.	July 28	BRAINERD,	MINN.	47
Wed.	July 29	WADENA,	MINN.	49
Thurs.	July 30	DETROIT LAKES,	MINN.	43
Fri.	July 31	PARK RAPIDS,	MINN.	54
Sat.	Aug. 1	BEMIDJI,	MINN.	
15th WEEK				
Sun.	Aug. 2	GRAND RAPIDS (M)	MINN.	73
Mon.	Aug. 3	AITKEN,	MINN.	54
Tue.	Aug. 4	MILACA (Nite only)	MINN.	62
Wed.	Aug. 5	Wayzata, W.Long Lake	MINN.	63
Thur.	Aug. 6	SHAKOPEE,	MINN.	18
Fri.	Aug. 7	MANKATO,	MINN.	52
Sat.	Aug. 8	WASECA,	MINN.	28
16th WEEK				
Sun.	Aug. 9	NORTHFIELD (Mat)	MINN.	45
Mon.	Aug. 10	RED WING,	MINN.	38
Tue.	Aug. 11	HASTINGS,	MINN.	26
Wed.	Aug. 12	RIVER FALLS,	WIS.	21
Thurs.	Aug. 13	MENOMINEE,	WIS.	42
Fri.	Aug. 14	NEW RICHMOND,	WIS.	43
Sat.	Aug. 15	RICE LAKE,	WIS.	63
17th WEEK				
Sun.	Aug. 16	LADYSMITH (Mat.)	WIS.	31
Mon.	Aug. 17	MEDFORD,	WIS.	69
Tue.	Aug. 18	MERRILL,	WIS.	36
Wed.	Aug. 19	ANTEGO,	WIS.	29
Thurs.	Aug. 20	SHAWANO,	WIS.	46
Fri.	Aug. 21	NEW LONDON,	WIS.	49
Sat.	Aug. 22	BERLIN,	WIS.	41
18th WEEK				
Sun.	Aug. 23	RIPON (Mat. only)	WIS.	19
Mon.	Aug. 24	WAUPUN,	WIS.	20
Tue.	Aug. 25	FORTAGE,	WIS.	41
Wed.	Aug. 26	REEDSBURG,	WIS.	34
Thur.	Aug. 27	RICHLAND CENTER	WIS.	34
Fri.	Aug. 28	VIROQUA,	WIS.	30
Sat.	Aug. 29	PRAIRIE DU CHIEN	WIS.	43
19th WEEK				
Sun.	Aug. 30	BOSCABEL (Mat.)	WIS.	
Mon.	Aug. 31	DODGEVILLE,	WIS.	
Tue.	Sept. 1	MONROE,	WIS.	
Wed.	Sept. 2	PLATTEVILLE,	WIS.	
Thur.	Sept. 3	MARSHALL,	IOWA	
Fri.	Sept. 4	ANAMOSA,	IOWA	
Sat.	Sept. 5	IOWA CITY,	IOWA	
20th WEEK				
Sun.	Sept. 6	TIPTON (Mat. only)	IOWA	
Mon.	Sept. 7	MUSCATINE (Labor Day)	IOWA	
Tue.	Sept. 8	WASHINGTON,	IOWA	
Wed.	Sept. 9	FAIRFIELD,	IOWA	
Thur.	Sept. 10	OTTUMWA,	IOWA	
Fri.	Sept. 11	KNOXVILLE,	IOWA	
Sat.	Sept. 12	OSKALOOSA,	IOWA	
21st WEEK				
Sun.	Sept. 13	ALBIA (Mat. only)	IOWA	
Mon.	Sept. 14	CENTERVILLE,	IOWA	
Tue.	Sept. 15	KIRKSVILLE,	MO.	
Wed.	Sept. 16	MACON,	MO.	
Thur.	Sept. 17	MOBERLY,	MO.	
Fri.	Sept. 18	MEXICO,	MO.	
Sat.	Sept. 19	FULTON,	MO.	
22nd WEEK				
Mon.	Sept. 20	HERMAN (Mat. only)	MO.	
Tue.	Sept. 21	COLUMBIA	MO.	
Wed.	Sept. 22	BOONEVILLE	MO.	
Wed.	Sept. 23	MARSHALL,	MO.	
Thur.	Sept. 24	LEXINGTON,	MO.	
	Sept. 25	WARRENSBURG,	MO.	
	Sept. 26	JEFFERSON CITY (Cancelled)	MO.	
23rd WEEK				
Sun.	Sept. 27	ELDON,	MO.	
Mon.	Sept. 28	CLINTON	MO.	
Tue.	Sept. 29	HARRISONVILLE,	MO.	
Wed.	Sept. 30	Eldorado Springs,	MO.	
Thur.	Oct. 1	LAMAR,	MO.	
Fri.	Oct. 2	CARTHAGE, (Mat.)	MO.	
Sat.	Oct. 3	MONETT, (Cancld.)	MO.	
24th WEEK				
Sun.	Oct. 4	MT. VERNON (Mat.)	MO.	41
Mon.	Oct. 5	COLUMBUS,	OKLA.	28
Tue.	Oct. 6	VINITA,	OKLA.	52
Wed.	Oct. 7	PRYOR,	OKLA.	23
Thur.	Oct. 8	NOWATA,	OKLA.	73
Fri.	Oct. 9	BARTLESVILLE,	OKLA.	
Sat.	Oct. 10	PONCA CITY,	OKLA.	
25th WEEK				
Sun.	Oct. 11	CALDWELL (Cancl.)	KAN.	54
Mon.	Oct. 12	ENID,	OKLA.	46
Mon.	Oct. 12	KINGFISHER,	OKLA.	38
Tue.	Oct. 13	ANADARKO,	OKLA.	79
Wed.	Oct. 14	SEMINOLE,	OKLA.	93
Thur.	Oct. 16	ADA,	OKLA.	36
Sat.	Oct. 17	McALESTER,	OKLA.	61
26th WEEK				
Sun.	Oct. 18	POTEAU (Mat)	OKLA.	69
Mon.	Oct. 19	MENA,	ARK.	56
Tue.	Oct. 20	NASHVILLE,	ARK.	48
Wed.	Oct. 21	ARKADELPHIA,	ARK.	53
Thur.	Oct. 22	CAMDEN,	ARK.	56
Wed.	Oct. 23	MAGNOLIA,	ARK.	50
Fri.	Oct. 24	HOPE,	ARK.	17
Sat.	Oct. 24	PRESCOTT,	ARK.	152
Mon.	Oct. 25	HUGO,	OKLA.	
		"Home Sweet Home" SEASON ENDS		
			Total Mileage	7766

Compliments of
JACK S. SMITH, AUDITOR
P. O. Box 392
Hugo, Oklahoma

Acme Printing Co., Hugo, Okla.

On the Road

A great deal of organization goes into any circus season. Office personnel plan the route for the weeks, months or years it will be on the road. (The Ringling Bros. and Barnum & Bailey show, for example, has a two-year season. By the end of it, no doubt many road-weary performers are eagerly crossing off the days as home sweet home comes closer!) Far in advance, circus staff must set up appearance dates, travel schedules and the delivery of goods like hay and animal feed. There can be hundreds of details to look after, from making sure performers can receive mail at every stop to finding daycare arrangements for performers with young children when necessary.

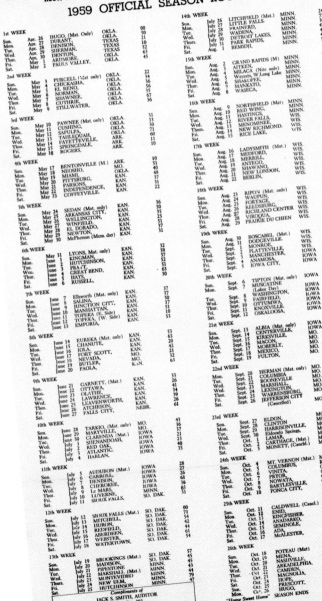

Daily Lessons

Some people dream about circus life as a time of nonstop play. Nothing could be farther from the truth. Performers who have grown up in the circus say that it's a good life, but often a difficult one. In fact, while children in the audience wish they could run away and join the circus, lots of circus children can't wait for the season to end so they

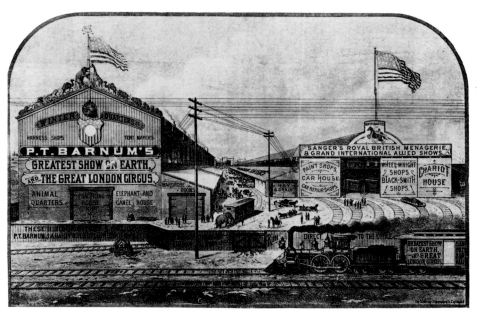

In the 1880s, performers created new acts, repaired wagons and rested during the months spent at the winter quarters in Bridgeport, Connecticut.

can live in their real house back at the winter quarters. They don't like having a different backyard every few days.

Children who perform in the circus probably have a tougher schedule than the kids in the audience. They have hours of lessons and practice in whatever circus skills they are learning. Many must become expert at several skills, such as acrobatics and juggling and horseback riding.

Then there are chores to do around the circus lot. The animals must be fed, groomed and rehearsed. The family's trailer home must be cleaned. In smaller circuses, the performers themselves are responsible for sewing and repairing their outfits. Even the children become skilled with a needle and thread and learn to find new ways to design the most efficient costumes for their particular act. (For example, sometimes a sleeve appears to be attached to a costume, but it is really only partially sewn on, so the arm can fully rotate.)

Not that long ago, the circus didn't provide an education for its young performers (some still don't). Instead, parents had to make the time each day to teach their children themselves. A child might be able to juggle clubs while standing backward on a trotting horse, but she might not be able to read or write. Today, some circus operators hire teachers and tutors as well as interpreters, and run a traveling one-room school where children of all ages learn together. (Cirque du Soleil students study twenty hours a week and still practice routines and perform in ten shows a week.) Correspondence school is also an option.

The lessons are organized around the circus-skills practice periods. Since many children come from different countries, the classroom is a wonderful place for everyone to learn about different cultures. Geography comes alive as the class visits each city on the route the circus follows during the season.

A mobile circus school looks like the inside of any classroom. There are maps, blackboards, computers and plenty of books. Quizzes, tests and report cards are all part of the circus student's life, too.

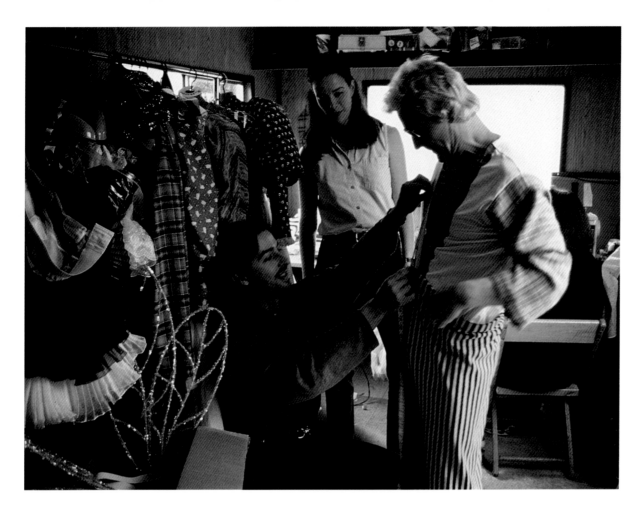

Daily life for circus performers includes costume fittings, hours of practice, and even some time for a favorite story.

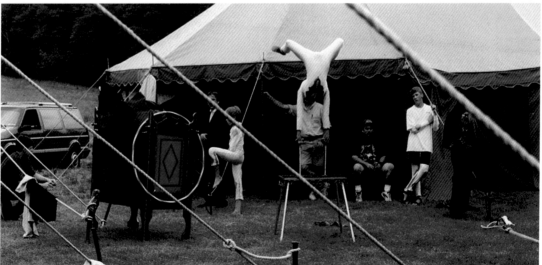

Scoffins

Just Desserts!

If you ever overhear a couple of circus people happily discussing cherry pie, don't think it's time for dessert! Cherry pie is circus lingo meaning extra pay for overtime work.

At the call "Flag's up!" a flag flutters from the top of the pie car—the truck, tent or railway car where performers go for meals, or "scoffins."

In the past, some cookhouse tents held more than a thousand people and served almost five thousand meals a day. If the circus was in town for only one day, the cookhouse staff had to have the dining tent and kitchen tent taken down, moved miles away to the next site and then put up again between suppertime and the next day's breakfast! As many as eight wagons carried the cookhouse equipment and supplies. There were hundreds of pies to be baked, gallons of coffee to brew and endless stacks of dishes to wash. (One circus traveled with a frying pan that was almost three feet in diameter, which cooked 144 eggs at once!) Then on to the next site.

Today, iceboxes have been replaced by modern refrigeration units. Wood and charcoal-burning stoves gave way to the latest stainless-steel ranges and ovens. Long ago, meat was usually fried or stewed, since circus wagons didn't carry conventional ovens. These days there's more talk of nutrition and stricter health codes. The pie car manager hires a nutrition specialist and cooks to feed performers who are as fussy about staying in top physical condition as any athlete.

Around 1900, the dining tables for the performers and circus officials were set with white linen tablecloths and real china. The workmen and lesser bosses were served on checkered cloths and enameled tinware. Performers were never allowed to associate with non-performers, and they sat on separate sides of the dining tent. Even the length of the tables differed. Workers sat at long tables; performers sat at short ones, more like restaurant dining tables.

In the early circus days, performers dressed up for meals. The men wore ties, and often vests and jackets, too. Waiters served the seated diners. Today's performers dress casually. Meals are a time for wholesome food, socializing, and perhaps a game of backgammon.

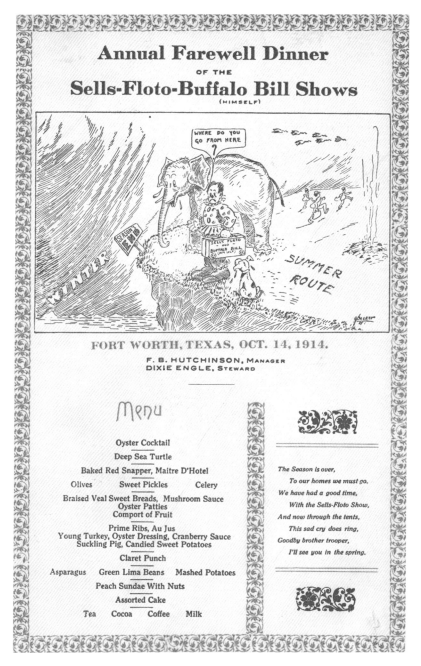

A special meal celebrates the end of another season of performances. This 1914 menu sounds exotic—and very filling!

Hatching, Matching and Dispatching

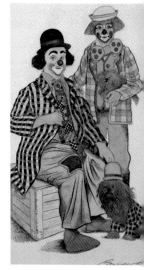

This clown couple is attended by a well-dressed pet!

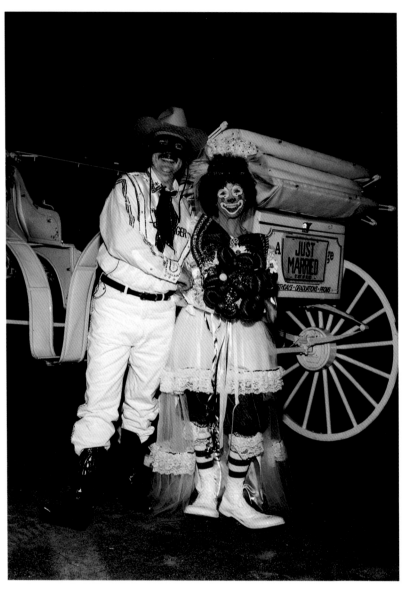

When Cranberry the Clown (Jan Shoor) married the Snow-a-Ranger (Howard Potter), the flower girl carried flour, and the bride threw a bouquet of balloons.

Birth, marriage and death are as much a part of circus life as any other. Children tour with the troupe, babies are born during the season and birthdays are celebrated.

Sometimes circus people fall in love and marry during their years on tour. Clown artist Bill Ballantine (page 88) met and married showgirl Roberta Light in the 1940s, when they both worked in the Ringling Bros. and Barnum & Bailey Circus. They eventually had five children, and their first son, named Toby Circus Ballantine, works with the American Circus Gatti.

The 1992 wedding of Ringling stars Dessie and Ivan Espana took place on a circus wagon in center ring before thousands of circus fans. Eighteen clowns and sixteen elephants were in attendance!

Performers don't always spend their entire working lives with one circus. They can move from troupe to troupe and from country to country, developing new acts. There's no definite retirement age in the circus; performers like Oleg Popov of Russia, Karl Wallenda and Switzerland's Grock continued to entertain well into their seventies. However, eventually the time to retire does come. In 1990, animal trainer Gunther Gebel-Williams (page 67) completed a two-year farewell tour and then, in the center of the ring, symbolically handed over his boots to his son, Mark Oliver Gebel. But it's not easy to leave circus life behind, and Gebel-Williams is now in charge of animal care for Ringling Bros.

Sudden death is always a possibility when people perform risky stunts, no matter what safety measures are taken. Some describe death as "going to the big lot." One has only to visit places like Sarasota, Florida, where many circus folk are buried, to see their memories reflected in monuments and epitaphs.

NEVER, NEVER!

Circus performers can be a superstitious lot. Just as a baseball player always puts on his left shoe first for good luck, so the following superstitions are respected in the circus.

• Never whistle in the dressing room.
• Boots, shoes or slippers should never be seen in a trunk tray or on a dressing table.
• Cannon-back (rounded top) trunks are bad luck.
• Never eat peanuts in the dressing room.
• Don't sleep inside the Big Top (this belief comes from the days when the ring was made of banked dirt, and people were afraid of being buried in the ring trench).
• Always enter the ring with your right foot.
• Never move a wardrobe trunk once it has been put in place. If you do, it means the performer will be leaving the show.

Developing a New Act

While many circus performers are trained in the basics—juggling, mime, acrobatics, etc.—and practice the skills each day, every performer wants to perfect one act that will make him or her a part of circus history.

Teachers of circus arts say that they're not looking for performers who are beautiful. Instead they want their students to use the bar, the rings, whatever apparatus, to tell a story without words, using only their bodies and revealing their feelings to the audience. This can be difficult to do when you're dangling from an arena ceiling!

Students confess that coming up with an act that no one else has done is an obsession. Has anyone ever juggled upside down? Has anyone ever completed seven revolutions from the trapeze? If not, it's worth further investigation. And years of practice.

For example, Misha Matorin, a native of Russia,

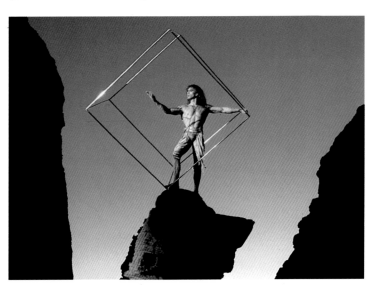

traveled North America with Cirque du Soleil in 1994. An aerialist, he incorporated into his flying act a dance in which his partner was a large lightweight steel cube frame. His routine was the result of ten years spent developing the act. "A circus performer," he explained, "spends a lifetime finding and perfecting a single act, and comes to be known by that act." The routine is meant to "create a portrait of life as an endless struggle between tyranny and freedom." That's a bit of a heavy message for a happy night at the circus, but it's exactly what the performers are trying to do—reveal their feelings to the audience.

Misha Matorin, like other circus performers before him, may become world famous for his special act. But he will have to keep it fresh even if he performs it for years. And he may have to reinvent his routine as he gets older and his body changes.

On with the Show

With your ticket grasped in a sweaty palm,
you finally head for the Big Top. You've bought your souvenir
program and a T-shirt.

Inside the tent, the seats fill up quickly. You climb up to
your seat, listening to the sounds that your shoes make on a
floor that's sticky from spilled cola. Candy butchers and rub-
bermen follow you inside and continue to sell popcorn, neon
light-sticks, funny hats and balloons. You may see a clown
walking around with a talking parrot. He stops to chat with a
boy in the front row.

Meanwhile, down in the ring, people are making last-
minute safety checks. Are the metal cables taut enough? Are
the crash mats and safety nets ready? Lighting technicians
have tested the colored lights. Someone has checked the dry-
ice machine for the clown act. The musicians are tuning their
instruments.

The audience is growing in size and noise level. Everyone
knows something wonderful is about to take place. More than
one hundred years ago, a writer captured the excitement:

> *Much that is comical,*
> *And anatomical,*
> *And astronomical, there you will find:*
> *Feathers and spangles,*
> *Tumbles and tangles,*
> *Circles and angles gayly [sic] combined.*

That's the circus! On with the show!

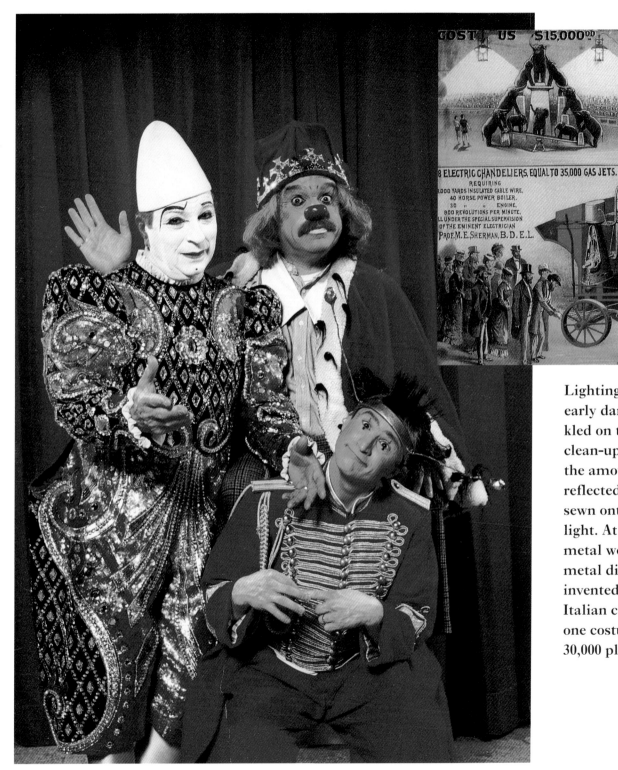

COST US $15,000.00

8 ELECTRIC CHANDELIERS, EQUAL TO 35,000 GAS JETS.
REQUIRING
3,000 YARDS INSULATED CABLE WIRE,
40 HORSE POWER BOILER.
30 " " ENGINE,
800 REVOLUTIONS PER MINUTE,
ALL UNDER THE SPECIAL SUPERVISION
OF THE EMINENT ELECTRICIAN
PROF. M. E. SHERMAN, B. D. E. L.

OUR ELECTRIC LIGHT.

THIS ENGINE & BOILER
WAS BUILT EXPRESSLY FOR US
BY THE FITCHBURG STEAM ENGINE CO.

Lighting was always a problem in the early dark arenas. Sawdust was sprinkled on the ring floor both for the easy clean-up of animal droppings, and for the amount of light the pale shavings reflected. Sparkling metal pieces were sewn onto costumes to reflect the light. At first, bells and other bits of metal were used, and then small metal disks called sequins were invented. (The word came from the Italian coin called a *zecchino*.) Today, one costume can have more than 30,000 plastic sequins attached.

The Ringmaster

Major DICK P. BARTON

"THE SMILING RINGMASTER"
of the
BRITISH CIRCUS RING

19 68 Season. Billy Smart's Circus.

200th Anniversary of Astley's Circus.
1768 — 1968.

Keep Smiling
Dick P Barton

It's easy to forget that a circus show is approximately two hours of *live* entertainment. No matter how skilled and practiced the performers are, anything can happen. Someone has to be out front, keeping an eye on everything, anticipating problems and quickly dealing with an emergency if it arises. That's the ringmaster's job.

The ringmaster is a position that has changed throughout circus history. Early ringmasters like Philip Astley held the reins of the circling horses. Later ringmasters, who wore red jackets, white breeches and black hats, directed the show, becoming masters of ceremonies who announced the different acts.

Today, a ringmaster (male or female) still plays the "straight man" for the clowns, still watches for any problems in the ring, still introduce the various acts. Many of them sing as well. The uniform has changed, too. During the 1994 season, the ringmaster of the Moscow Circus wore a baggy black suit, spats and an oversized black top hat. American ringmasters may change costumes many times during the show, displaying one dazzling sequin-encrusted jacket after another. The ringmaster of the Big Apple Circus wears a traditional riding habit.

The ringmaster grandly introduces each act to the audience. He calls the performers back for their bows. He smiles and welcomes everyone as if they've entered his living room. And, in a way, they have. When he blows his whistle and slowly calls out "Laaadeeeeez and gentlemen, boys and girls, chillll-dren of all ages..." the magic begins.

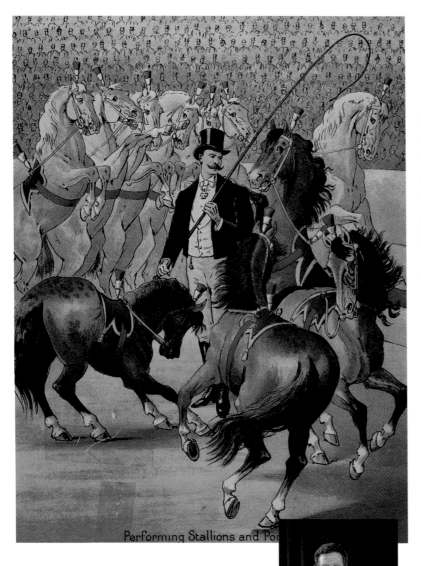

Performing Stallions and Po[...]

Ringmasters (like Paul Binder of the Big Apple Circus) often wear versions of a traditional riding outfit.

Windjammers

Cirque du Soleil's musicians in the show *Alegria* wear theatrical costumes and play instruments ranging from a traditional accordion to a modern electric guitar.

The members of a circus band are called windjammers. The music they play may include marches, reggae, calypso, barbershop, even rap—whatever fits the individual circus act. Some circuses, like Canada's Cirque du Soleil, perform to a completely original score that has been written especially for the show.

The band serves as a clock, too. Performers behind the scenes know which act is on by listening to the music. And while performing, they time their acts by the beats, and follow the pace set by the music.

The musicians must closely follow every move made by the circus performers. A turn of the performer's head, for example, may signal to the musicians that a change is coming. In fact, if you go to the circus night after night during an engagement, you will never see an act performed exactly the same way each time. The constant changes keep the routine fresh, as the performer finds tiny ways to refine the act.

The music tells the audience when to get noisy and when to hush. Loud, romping tunes highlight the livelier acts; gentler music (or no music) accompanies the intense concentration of a performer who is perched high above the crowd. The music can distract the audience, perhaps by playing loudly and making a funny sound when the juggler drops a club. If a horseback rider misses his leap onto the back of a steed and has to wait for another opportunity, the band has to continue playing until the act has "caught up."

Circus bands have been warning devices, too. If a disaster occurs, like the great Ringling Big Top fire in 1944, the band is prepared to play a certain song that signals rescue workers and the performers to help the audience exit.

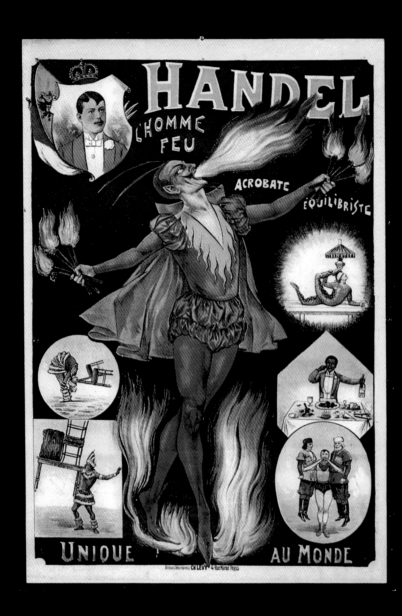

Spectacular thrill acts, like Handel, "The Man of Fire," were guaranteed crowd-pleasers. His costume glowed with flame colors and designs, and his makeup projected a sinister ferocity.

Awesome and Amazing Aerial Activities

The circus generally opens with a "spec," when the entire company parades around the ring. Then it's time for a carefully choreographed series of acts that generally fall into one of four categories—thrill acts, animals, ground acts and clowns.

Thrill, or daredevil, acts can make an audience hold its collective breath. In the 1800s, "Professor Baldwin's Great Drop from the Clouds" was a parachute act sure to make people gasp. Roman chariot-racing was another, as the air filled with dust pummeled from the ring floor by the noisy, dangerous hooves of the horses, and the riders desperately tried to keep from being thrown out of the carts. Or human cannonballs were fired with a loud boom and a flare that distracted the audience, while the "cannonball" hurtled through the air into a carefully placed net.

Today's thrill acts include the Globe of Death, a metal-mesh sphere containing three motorcyclists who dangerously drive at speeds of up to 60 miles per hour as they try to avoid crashing into one another. Or the Wheel of Death—twin metal-mesh cylinders that move constantly, circling high above the ring while a performer walks around the *outside* of the moving apparatus.

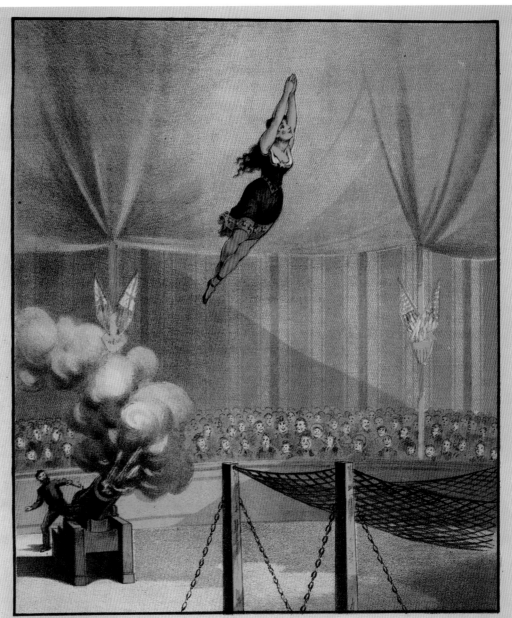

An Aerial Flight. 15

Behold, they bring the cannon forth!
 There is a flash! a sound [mouth
That shakes the earth ; and from its
 A missile with a bound

Ascends in air, and then is caught
 Within a net displayed
To check your fear that none are near,
 To ease the cannonade.

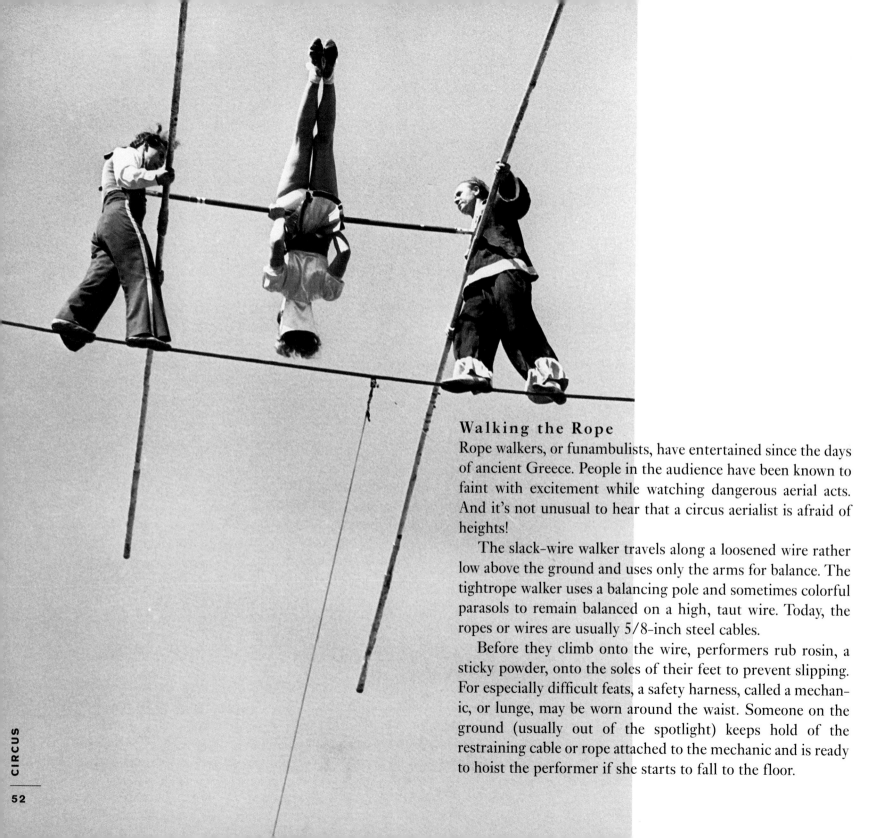

Walking the Rope

Rope walkers, or funambulists, have entertained since the days of ancient Greece. People in the audience have been known to faint with excitement while watching dangerous aerial acts. And it's not unusual to hear that a circus aerialist is afraid of heights!

The slack-wire walker travels along a loosened wire rather low above the ground and uses only the arms for balance. The tightrope walker uses a balancing pole and sometimes colorful parasols to remain balanced on a high, taut wire. Today, the ropes or wires are usually 5/8-inch steel cables.

Before they climb onto the wire, performers rub rosin, a sticky powder, onto the soles of their feet to prevent slipping. For especially difficult feats, a safety harness, called a mechanic, or lunge, may be worn around the waist. Someone on the ground (usually out of the spotlight) keeps hold of the restraining cable or rope attached to the mechanic and is ready to hoist the performer if she starts to fall to the floor.

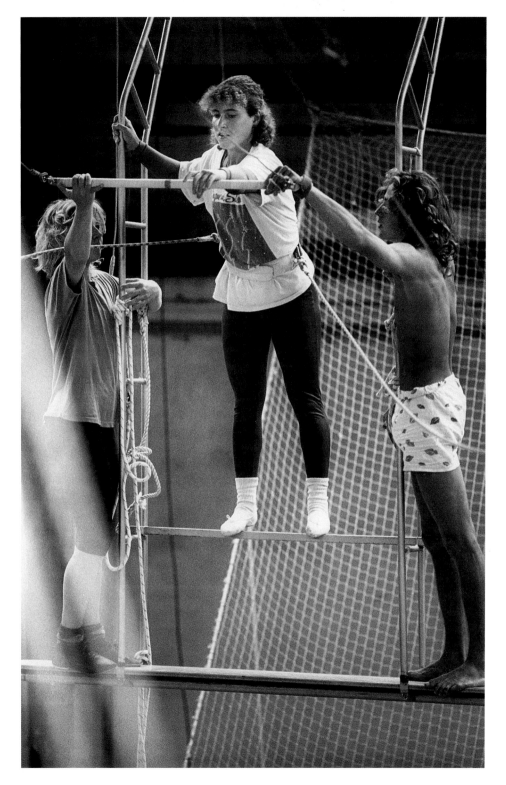

A Balancing Act

Circus administrators and fans have long debated the use of safety equipment during live performances. No one, however, argues about the use of lunges and nets during practice sessions. While someone is learning a new move, belts, ropes and nets assure his safety until the move is perfected.

During a show, though, the audience often thinks the professionals are less prepared or talented if they are attached by ropes to the ceiling of the tent. No ropes means more danger, and therefore more excitement, to many fans. Some performers argue that the safety ropes can sometimes actually cause problems when they get in the way.

What the audience sometimes forgets is that every aerial act is indeed extremely dangerous. Many things can affect a performance—the temperature in the tent, the moisture on the cable, the health of the individual that day, even the audience and its noise. (Audiences around the world react differently to circuses. In Japan, the spectators are very quiet, as if they don't want to disturb the performers. In America, the excited fans hoot and whistle as they enjoy the show.) The performer's concentration during an act must be intense, because she is holding her life—and maybe someone else's—in her hands.

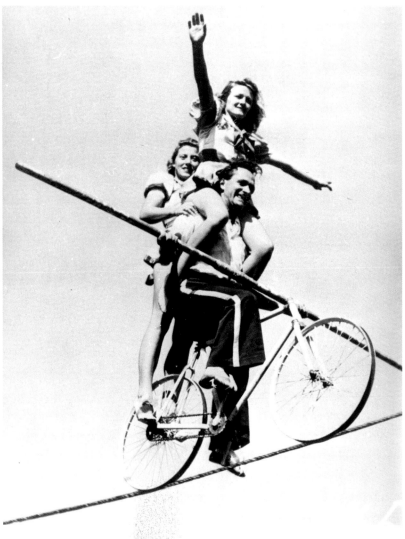

By the age of nineteen, German-born Karl Wallenda was already the most famous wire walker in the world. The descendant of a circus family, Karl walked across the Danube River on a cable in 1923. Before him, tightrope performers simply walked across the wire. Wallenda decided to toss in some incredibly dangerous acrobatic feats.

Wallenda married and fathered a new generation of Wallenda aerialists. By 1928, the Wallendas were dazzling audiences for the Ringling Brothers circus. They worked without a net, on a wire forty feet above the ground. They walked or rode bicycles across the wire, all the while balancing a pyramid of Wallendas on a series of poles attached to chest harnesses. Sometimes the "topper" Wallenda even balanced on a chair.

Falls are sure to occur during such dangerous acts, and the Wallenda family suffered its worst tragedy in 1962, when the lead "understander" slipped, and the seven-person pyramid collapsed. Two of the troupe members died when they fell to the concrete floor. Another broke his back. Two days later, however, the Wallendas were back on the wire with replacements.

"On that wire is your life," said Karl Wallenda. "Below is your death." At the age of sixty-five, he set the world record for the highest high-wire act when he walked across the Tallulah Gorge, Georgia, on a wire 750 feet above the ground. He crossed the 233 yards in about fifteen minutes, entertaining the onlookers with two head-standing pauses on the way!

At an age when others considered themselves comfortably retired, Karl Wallenda continued to dazzle crowds. In March 1978, however, a sudden gust of wind caused him to fall ten stories to his death from a wire stretched between two hotels in San Juan, Puerto Rico. A circus great was gone, but present-day Wallendas carry on the family tradition with their amazing high-wire acts.

Famous for high-wire acts, the Wallenda family practices their famous, and dangerous, seven-person pyramid. In 1997, the Guerrero family performed the act, so awesome that it silenced huge, noisy audiences who watched breathlessly.

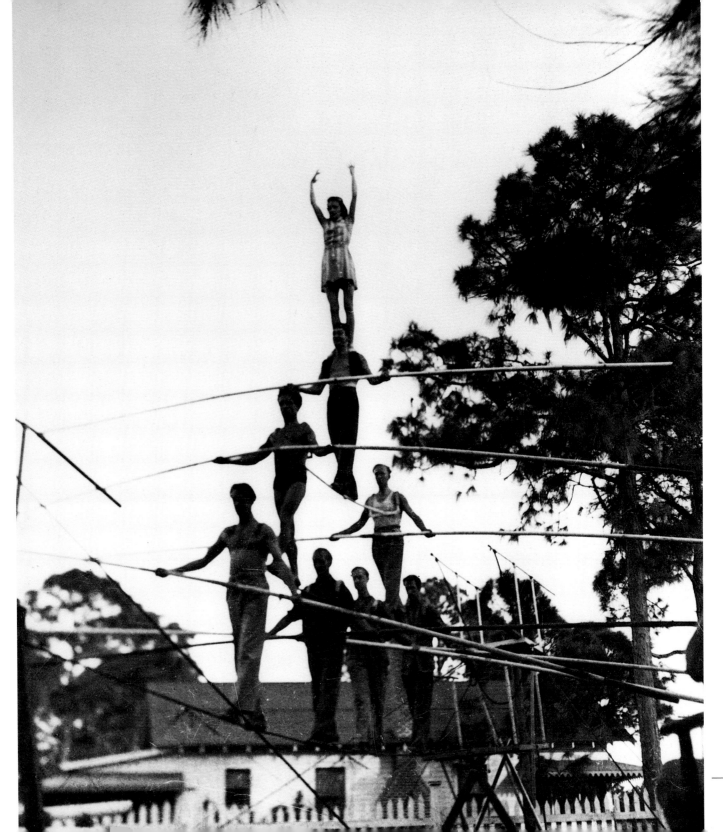

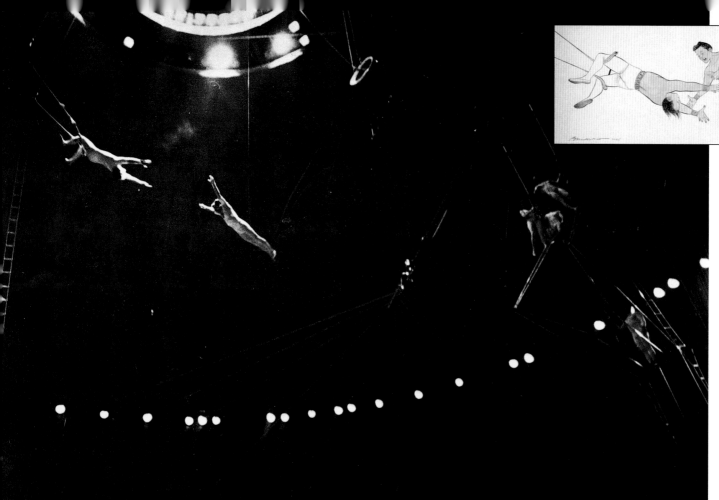

A drawing by Bill Ballantine captures the artistry of the flying trapeze.

Oleg Lozovik of the Moscow Circus catapults through the air with amazing speed and accuracy.

Tantalizing Twists and Turns on the Trapeze

Whether they are working on a still trapeze, dangling from a single swing trapeze or reaching incredible speeds on the flying trapeze, "trap" artists combine acrobatics, amazing strength and a perfect sense of timing.

Through the years, there have been plenty of notable trapeze acts. Lulu, a blonde who dazzled the audience, later turned out to be a man. Jules Leotard, inventor of the bodysuit. Ian Ashpole, who in 1986 performed the highest trapeze act, suspended from a hot-air balloon hovering three miles above the ground.

In 1920, the reckless Alfredo Codona, "King of the Trapeze," became famous for his triple somersaults, which took him three years to perfect. To complete such a feat, the flyer must move at almost seventy miles per hour in order to roll and fly into the hands of the catcher, who must be at exactly the right place at the right time. Such acts are so dangerous that there is usually a safety net underneath.

Miguel Vazquez, only seventeen years old, made history in 1982 when he executed the first quadruple somersault from a flying trapeze in performance. That record has yet to be broken. Meanwhile, trapeze artists like the Moscow Circus's Flying Cranes and the Russian Kaganovitch Flyers have worked quadruples into their mesmerizing acts. Could a quintuple somersault happen one day?

Daring Young Men

A century ago, performers wore costumes made in the fabrics that were available at the time. But the scratchy, heavy cotton or wool added to the weight the performers had to carry. The clothes and tights took a long time to dry, and people complained that their tights stretched—producing "grapefruit knees." Women wore bulky bloomers, and even they were considered scandalous at the time.

Today, circus performers wear quick-drying, close-fitting bodysuits. Jules Leotard (1842-1870) is credited with the invention of this outfit.

Leotard was a well-known trapeze artist who

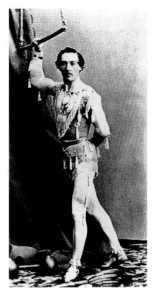

performed all over Europe. He was the first aerialist to "fly" from one moving trapeze bar to another. Although he died of smallpox when he was only twenty-eight years old, his name lives on, thanks to the leotard and "The Daring Young Man on the Flying Trapeze," the song that was written about him in 1868:

He flies thro' the air with the greatest of ease,
The daring young man on the flying trapeze.
His movements are graceful; all girls he does please,
And my love he's purloined away.

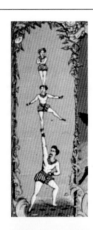

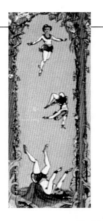

OTHER AERIAL ACTS

• **Spanish Web:** a canvas-covered rope with a loop for the performer's hand or foot; used for spectacular spins

• **Roman Rings:** two rings attached to hanging ropes and used together or singly, as a swing, for instance

• **Washington Trapeze:** a trapeze with a head stand attached to the center of the bar, named after the inventor, Keyes Washington

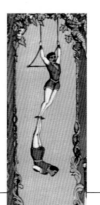

• **Cradle Act:** uses the cradle, a stationary tubular steel platform high above the ring; one performer hangs upside down from it while a second person swings, spins, etc.

• **Iron Jaw:** a device inserted into the mouth, allowing the performer to hang and spin by the teeth

• **Cloud Swing:** a rope suspended from both ends, with or without loops; the performer can sit, stand, hang, lie down or spin

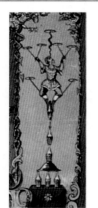

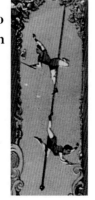

Circus Controversy #1: Animals

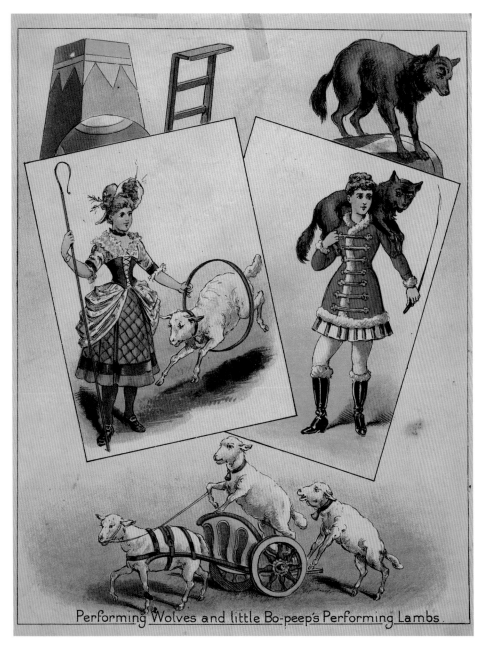

Performing Wolves and little Bo-peep's Performing Lambs.

A page from a Victorian children's book is filled with young animal performers.

Animals.

Just that one word can raise the temperatures of circus owners, performers, fans and detractors. A circus program today is sure to contain an animal welfare statement discussing the circus's commitment to the animal members of its family. Find a circus, and groups of animal rights activists are sure to be close by. Some circuses have eliminated animal acts altogether.

What is a circus fan to make of the gruesome photographs and stories describing the horrors of animal life in the circus?

It's no doubt true that some circuses don't care for their animals as well as they should. During a show, audiences can sometimes see unkempt animals cowering, being prodded by poles, snapped at with whips or screamed at.

Animals in the ring date back to ancient times, and many people come only to see the bear dance, or the tiger jump through a flaming hoop. Other people squirm in their seats when the chimpanzees rush out, dressed and performing like humans.

Should wild animals be left in their natural habitats, or raised in captive breeding programs sponsored by some circuses or private foundations? People argue that such programs protect certain animals, like tigers, from extinction. Others say it's degrading to keep animals in cages and to make them perform for humans. Some animals actually receive health-care and dental benefits just like human circus performers. Others are worked to death.

As long as animals are a part of the circus world, there will be heated debate about them.

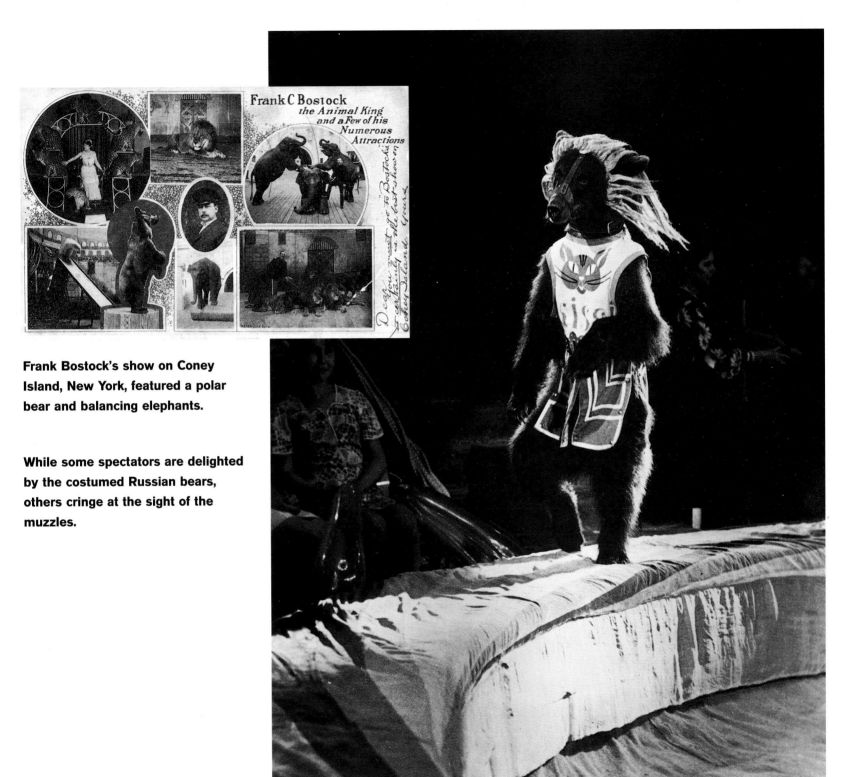

Frank C Bostock
the Animal King
and a Few of his
Numerous
Attractions

Frank Bostock's show on Coney Island, New York, featured a polar bear and balancing elephants.

While some spectators are delighted by the costumed Russian bears, others cringe at the sight of the muzzles.

The Elephants

Andrew Ducrow (page 11) is credited with being the first to use elephants in a circus. But circus owners everywhere soon found that the sight of the two-ton giants parading through town, sporting colorful shawls embroidered with spangles and beads, was sure to fill the streets with onlookers.

These giants require a huge amount of care. They must be kept in good health with daily baths (more than one on very hot days). Elephants eat hundreds of pounds of food each day, including grain, horse feed, vegetables and fruits. The Ringling Bros. and Barnum & Bailey Circus reportedly serves up 73,000 pounds of elephant chow to about a dozen animals each year in just one branch of their traveling operations.

Generally, Indian elephants are used in the circus because they are considered easier to train and less temperamental than African elephants. Trainers work long days as they feed, groom and exercise the animals, rehearse with them and finally perform. Some trainers work with the elephants from the time they are born, and they end up having huge respect and affection for their animal colleagues.

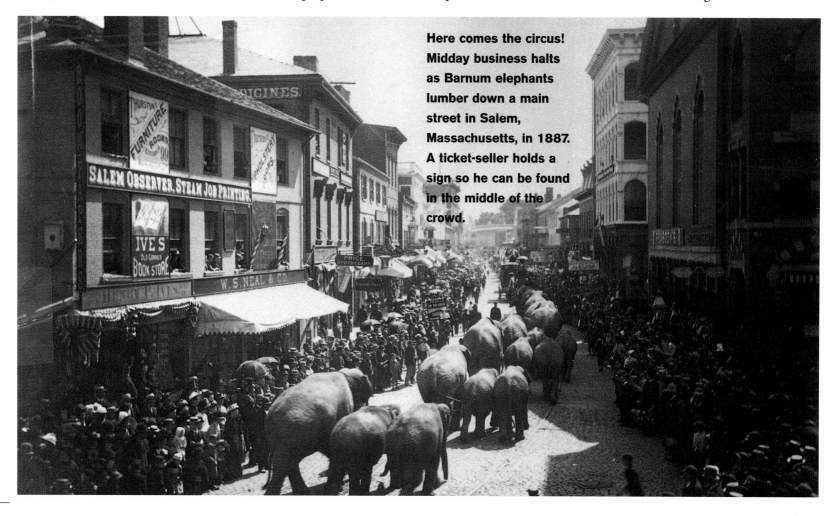

Here comes the circus! Midday business halts as Barnum elephants lumber down a main street in Salem, Massachusetts, in 1887. A ticket-seller holds a sign so he can be found in the middle of the crowd.

Jumbo

"The Towering Monarch of His Mighty Race" was an African elephant who lived at the Royal Zoological Gardens in London, where children rode on his back. In 1882, Jumbo was bought by P.T. Barnum for the enormous sum of $10,000 (about $200,000 today) and transported to New York. When the English learned of the sale, a letter-writing campaign began in protest. Even Queen Victoria declared that she didn't want Jumbo to leave the country. Nevertheless, the transaction took place.

Barnum enjoyed every bit of the publicity. Within two weeks of arriving in the United States, Jumbo had generated enough extra sales to pay for his own cost and shipment. Jumbomania seized the world.

Jumbo was eleven feet high and weighed about seven tons—big, even for an elephant. He didn't do tricks; he just walked around the ring in front of audiences that had never seen such an enormous animal. While some elephants were used to help put up the tents, Jumbo was reserved as a parade animal. He traveled around North America in a special red and gold train car.

In a famous stunt, Jumbo's trainer led him across the new Brooklyn Bridge in New York to prove that it was sturdy enough for heavy traffic. Companies began to use Jumbo's image to advertise products like thread, baking powder and laxatives. Jumbo even became the name of a color shade that was ... elephant gray.

But Jumbo's career with the circus was short. In 1885 he was accidentally struck by a freight train.

Barnum told reporters that Jumbo had lost his life saving a tiny elephant companion. It was a story sure to bring a tear to every listener's eye, and Barnum made the most of it. There were rumors that Jumbo was getting too old to continue with the circus, and that the accident fed Barnum's publicity machine with a showier end.

Never one to miss an opportunity, Barnum gave the public what it wanted: Jumbo, dead or alive. He toured with Jumbo's skeleton and mounted hide. Eventually the skeleton was given to the American Museum of Natural History in New York City. The 1,500-pound hide was given to Tufts University in Massachusetts, but was destroyed by fire in 1975. All that remains is a portion of Jumbo's tail, a bit of tusk, and a peanut butter jar full of his ashes. Jumbo continues to serve as the college mascot, and athletes rub the jar for good luck before a game. Meanwhile, the word Jumbo lives on, used to describe anything larger than average.

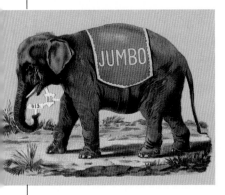

'Twas Jumbo here, and Jumbo there, and Jumbo everywhere;
'Twas Jumbo all along the streets where there was room to spare;
To see His Royal Highness other shows the crowd forsake,
And all declare with emphasis that Jumbo "takes the cake."

The Children's Circus and Menagerie Picture Book, 1882

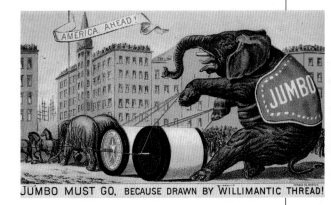

JUMBO MUST GO, BECAUSE DRAWN BY WILLIMANTIC THREAD!

Gargantua

Another huge circus animal grabbed the public's attention in the 1930s and 40s. Gargantua the gorilla was the star attraction of the Ringling Bros. and Barnum & Bailey Circus. His story, like Jumbo's, adds fuel to the arguments of animal rights groups.

Through injury, Gargantua's face was permanently fixed in a sneer that people found frightening. On posters he was shown rampaging, billed as the "World's Most Terrifying Living Creature."

The gorilla was not the largest of his kind, and he didn't perform tricks. But he was called a brute and was said to have the strength of twenty-seven men. He supposedly weighed 650 pounds (after his death, he was found to weigh about half that amount). He never left his air-conditioned cage, where his pacing convinced the audience that he was a wild beast to be feared. Inside his prison, gawked at by millions of people that he couldn't hear through his glass walls, Gargantua "sneered" and played with a tire.

The show continued. Gargantua was "married" to another gorilla, Mademoiselle Toto, in 1941, at a ceremony complete with processional march and flowers. (The bride and

groom were kept in separate cages.) The couple toured eight months a year; the rest of the time they lived at the circus's winter quarters.

Today it is easy to criticize what was done with these animals. However, at the time the practices were considered quite acceptable.

During World War II, Mr. and Mrs. Gargantua the Great were featured in a bond campaign that raised money for the war effort. After twelve years in his cage, Gargantua died of pneumonia.

The Horses

In the early days of the circus, most audiences were very familiar with horses. They were used in everyday life for transportation and as work animals. But circus horses were special. Philip Astley's equestrian shows proved that a horse could be trained to do much more than pull a plow. Trick riders, often former cavalrymen, somersaulted from horse to horse, thrilling the audience.

Elsewhere, jugglers rode while spinning plates on tops of canes in each hand. Horses jumped through flaming hoops. "Clever" horses tapped out answers to carefully prepared questions.

Some horseback stunts have historical roots. *Djigit* riding (incorrectly named Cossack riding) is based on the mountain riders in Russia who learned how to position their bodies on a horse so they could travel on narrow trails, dodge trees and jump over obstacles. *Djigits* learned to ride on the far side of a horse so they did not expose themselves to their enemies during battles. Swinging rapidly on and off the saddle also gave the enemy a less certain target.

Thundering hooves, shouting riders and incredible speed are now the trademarks of Russian trick riders. How do they keep their balance while standing tall on horseback? Science is the answer. The standing rider is pushed away from the center of the circle by centrifugal force. If the rider leans into the circle, against the tension, he is held in a balanced position. This does not mean that the rider has an easy job staying atop his steed; it just means he has a little help.

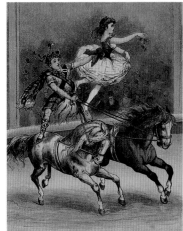

The elegant May Wirth was proclaimed "the finest equestrienne in the world" in the 1920s. While blindfolded, she could somersault from one moving horse to another.

Fanciful costumes adorn these young balancing riders in an old children's picture book.

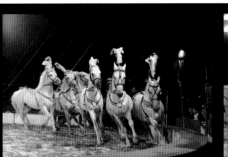
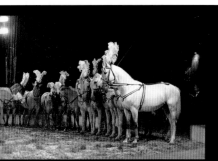

Liberty horses (so named because they are "at liberty," without reins) entertain the audience at the Bouglione Circus in France.

The Cats

In a high-walled cage of steel bars, lions roar from their platforms. A brave man wearing a pith helmet and carrying a chair loudly cracks a whip as the audience watches ... and waits.

The tigers and lions that perform in the circus are in fact extremely dangerous. A wild animal may be trained, but it cannot be tamed, and trainers (who include women like Claire Heliot and Olga Borisova) usually have the scars to prove it. The animals are not declawed or defanged. It is their natural urge to kill, not hunger, that drives the big cats to lunge at people, and even the most proficient trainer never forgets that his "playmates" are potential killers.

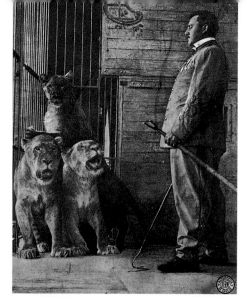

A 1905 postcard (left) shows the stern Dompteur Georgiano and three of his charges.

"The Lion Tamer" (below) foolishly turns his back on a lioness, while he attempts to maintain order in the cage.

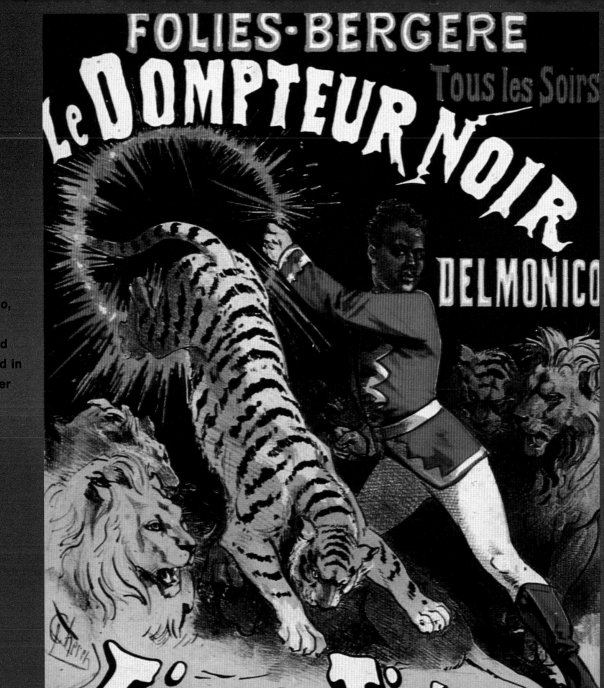

In 1876, Delmonico, the "Black Lion Tamer," entertained nightly in Paris and in this dramatic poster by Jules Cheret.

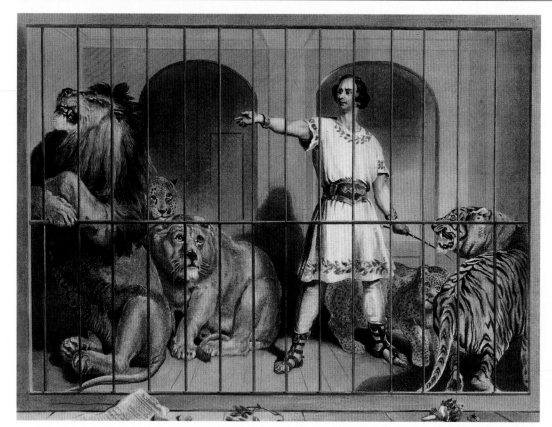

The Durovs: Anatoly (1864-1916) and Vladimir (1863-1934)

Russia's Durov brothers entertained circus fans, but they also wanted to stir them into action against social injustice. Their trained animal acts and serious clowning did both.

Vladimir's gentle approach to animal training, which was called "mild training," influenced all Soviet training programs and is still followed by many trainers. Durov animals did not perform out of fear, but for encouragement and a tasty treat. Their animals could indeed perform incredible acts. In one routine, for example, a pig, pelican, monkey, dogs, cats and a sea lion appeared as pupils. They sat on benches, turned book pages and wrote on a blackboard!

The brothers poked fun at the unfair politics of the day by using animals to represent government officials in some skits. This left the poorer audience members laughing at the richer people present, but it also angered the government, to the point that the Durovs sometimes found themselves evicted from cities. Their methods of clowning are known as the Durov method, and descendants of the two brothers carried on the tradition.

Isaac Van Amburgh (1808-1865)

Of Native American descent, Van Amburgh dazzled audiences in the 1830s when he became the first man to enter a cage full of wild animals. His early work with a menagerie developed into a circus routine, and he is credited with creating the first modern trained wild animal act.

What a show it was! Dressed like a Roman gladiator, complete with sandals, Van Amburgh tackled the lion before it could attack him, and used brute force to prove himself the master of the situation. He became famous for putting his head inside a lion's mouth, a trick that was sure to silence the noisiest audience. It's no wonder Van Amburgh was called "The Lion King"!

Clyde Beatty (1903-1965)

American Clyde Beatty ran away to join the circus when he was a teenager, and he began working with animals as a cage boy. Before long, he was a brash animal trainer, complete with chair, a blank-firing gun, and a popular fighting act with lions. Hollywood called, and Beatty, wearing spotless safari clothes, appeared in popular movies.

Although critics condemned Beatty for his assumed rough treatment of animals, his popularity grew. He fearlessly combined animals with their natural enemies in "mixed acts" (for example, lions and tigers in the cage together), performed with his famous lion Nero, and intently "stared down" the beasts in the cage. Eventually, the superstar opened his own circus.

Quick to call himself an animal trainer, not tamer, Beatty worked with animals, including seldom seen

polar bears, for more than forty years. His record for handling more than forty lions and tigers at one time still stands.

Gunther Gebel-Williams (1934-)

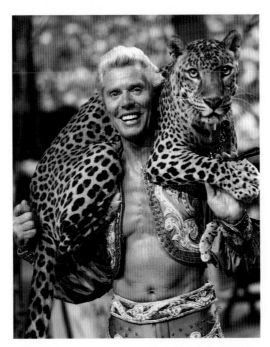

The world's most famous animal trainer, Gunther Gebel-Williams can charm both an audience and his performing animals. Born Gunther Gebel in Germany, he joined the famous Circus Williams when he was twelve. He worked primarily with the horses and elephants, riding *djigit*-style in the shows. When Gebel was sixteen, the circus owner died, and Gunther adopted his name. He was also invited to take charge of the circus.

Gebel-Williams became famous throughout Europe for his mixed animal acts. His training style differed from Clyde Beatty's: "I taught the tigers to listen, and still be tigers. I never tried to break their spirits and so I did not use brutality." He works with animals from infancy and speaks to the elephants in a tangle of French, German and Hindu. Before he retired in 1990, vacations were unheard of, and fifteen-hour workdays were quite usual.

Gebel-Williams debuted in North America in 1969. His wife Sigrid, his daughter Tina and son Mark Oliver continue the Gebel circus tradition. Gebel-Williams is now in charge of animal care for the Ringling circus, and can still be seen at performances. And there's always talk of a comeback tour!

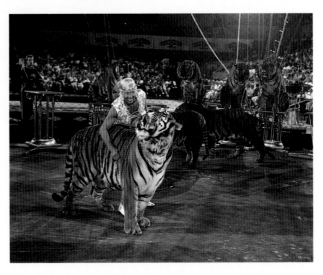

A Victorian children's book displays the elastic talents of contortionists "Les Grotesques Comiques."

Les 3 Williams (right) perform precision hand balancing in the early 1900s. Eighty years later, audiences at the Big Apple Circus are awed by the same kind of skill and artistry (below).

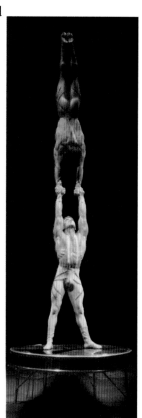

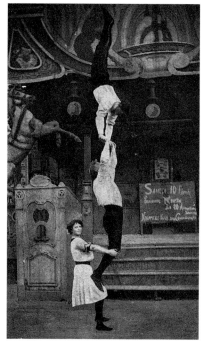

Foot juggling is the art of Risley, named after Richard Risley Carlisle and his son , who performed the act in the 1800s. The antipodist lies on his back in a cradle called a trinka and juggles another person with his feet.

Cirque du Soleil's young performers are adept at bending into incredible, artistic poses. Their close-fitting leotards streamline the act and the lines of their bodies.

VETING REVELRY

Coordination and cooperation are needed for this balancing feat. The performer (with Circus-Circus Las Vegas) balances on a rola-bola (board and cylinder), which keeps moving.

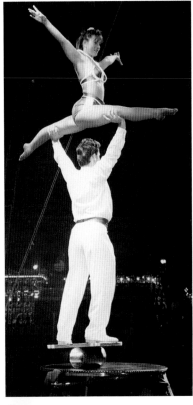

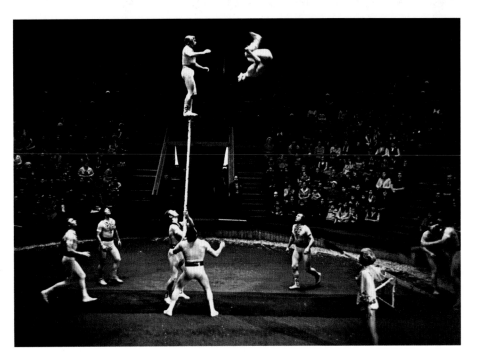

The Zamotkins use teeterboards to catapult themselves into the air and onto the shoulders of another acrobat, perched high on a pole. Other members of the Moscow Circus troupe "spot" the tumbling flyer, for his safety and that of the audience.

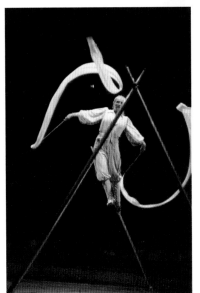

While walking the slack wire, Sasha Dmitri of the Big Apple Circus draws designs in the air with her ribbons. The lighting engineer highlights the performance with colored lights.

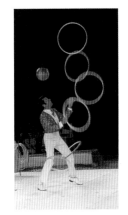

Imagine bouncing a ball on your head and, at the same time, tossing and catching hoops in the air AND keeping another ring revolving around your leg!

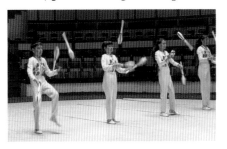

Young jugglers with the Bouglione Circus toss their clubs into the air with lightning speed and daunting accuracy.

And suddenly the motion stops. Bodies leap from the ring ... and other bodies rush in. It's time for the clowns!

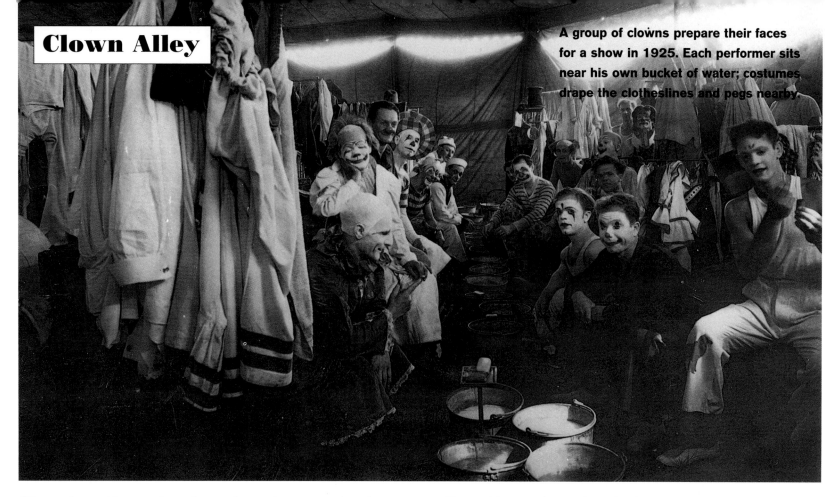

A group of clowns prepare their faces for a show in 1925. Each performer sits near his own bucket of water; costumes drape the clotheslines and pegs nearby.

Throughout history there have always been people who can make other people laugh. Early clowns, from the *stupidus* of ancient Rome to the court jester, often both offended and delighted listeners with their comments and songs. They were not the silent performers seen in today's circus rings. Clowns lost their voices when the large dimensions of three-ring circuses made it impossible for the audience to hear them.

There are different categories of circus clowns. Walk-around clowns use an animal or a prop, like a huge rubber hammer, as part of their routines. A carpet clown mingles with the audience and performs while the acts change in the rings. Then there are acrobatic clowns, riding clowns, juggling clowns and others. They all join in the charivari, the noisy entrance of the clowns.

Everything a clown does looks easy, but it's not. Making people laugh can be hard work.

Clowns must be in good physical condition to prevent injuries. Each slapstick move is carefully timed and well rehearsed. Most clowns have also been trained as acrobats, jugglers or aerial artists, and many incorporate such skills into their acts.

Clown alley—from the old ringmaster's call, "Clowns, allez" (French for "go")—is the name of the dressing area where the clowns put on their makeup and costumes. This area is usually near the entrance to the arena because of the frequent number of costume changes, the many props to grab, and the need for the clowns to be ready at all times to hustle out into the ring.

The word "clown" first appeared in the late 1500s as *cloine*, **or** *cloyne*, **meaning clumsy fellow, or fool.**

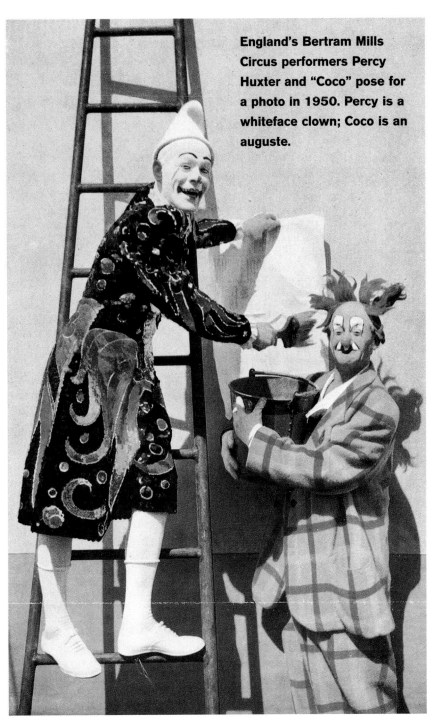

England's Bertram Mills Circus performers Percy Huxter and "Coco" pose for a photo in 1950. Percy is a whiteface clown; Coco is an auguste.

A Clown for Every Occasion

Generally, there are three categories of circus clowns—whiteface, auguste and character. Each has a specific makeup style and costume. Each has a typical act as well.

The neat whiteface is usually a strict, in-charge character who sets up the punch line for the joke with a partner who is typically an auguste. His facial features are neatly detailed in red or black, and his outfit looks something like loose pajamas with a ruffle around the neck.

Circus legend has it that the auguste clown got his name from a German nickname for someone who is clumsy. The auguste wears light-colored makeup, but white is used around the mouth and eyes, and there's a big red nose. This clown performs a great deal of slapstick humor. An oversized suit or baggy pants with suspenders allows freedom of movement for all the clumsy tumbles he takes. He also wears big shoes.

Character clowns perform as different personalities—cowboys, scarecrows, grandmothers or symphony conductors. The most famous character clown, however, is the tramp. Tramps wear different styles of makeup and costumes that are torn or shabby. Some tramp clowns are happy-go-lucky. Others are extremely sad. Still others act like gentlemen who just happen to be out of money.

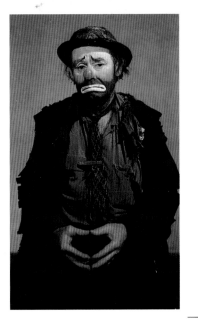

Emmett Kelly's character "Weary Willie" was one of the world's most famous tramp clowns. A clothespin served as a tie clip, and his suit was held together with safety pins.

A COLLECTION OF COLORFUL AND CACOPHONOUS CLOWNS

Joseph Grimaldi (1779-1837)

The English son of a clown, Joseph Grimaldi was on stage by the age of two. He sang silly songs, told jokes and did magic tricks. Grimaldi's life offstage, however, was less humorous. A famous circus story tells of a depressed man who went to see a doctor. The doctor could find nothing physically wrong with the fellow. "Go and see Grimaldi," he said. "He'll cheer you up." "I am Grimaldi," said the patient.

In the circus world, Joseph Grimaldi's name lives on every time a clown is called a joey. Britain's popular comic Rowan Atkinson (Mr. Bean), like Grimaldi, uses mime punctuated by a few words, like "Nice!"

Joseph Grimaldi is remembered by fellow clowns at the annual Clowns' Service, held at Holy Trinity Church in Dalston, England. Those attending come in costume, and after the service there are plenty of clown antics in the church hall.

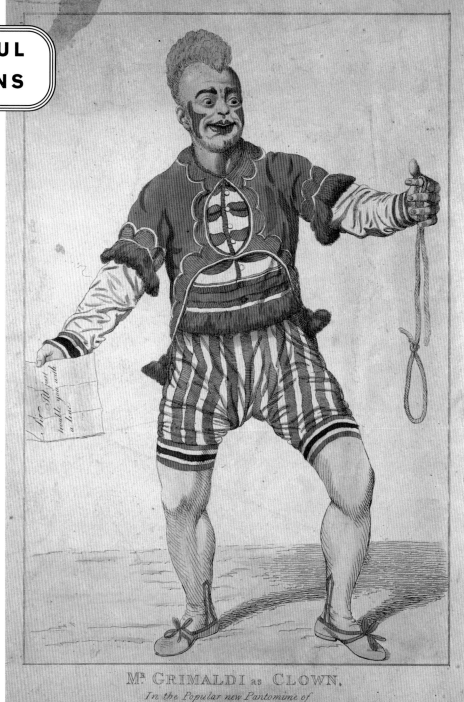

Mᴿ GRIMALDI as CLOWN,
In the Popular new Pantomime of
MOTHER GOOSE.

Price 2.6 colour'd
Published Feb 14 1807 by S. De Wilde Nᵒ 9 Tavistock Row,
Covent Garden.

Dan Rice (1823–1900)

Dan Rice was America's first great clown. He was a singer, strongman and jester. One of his routines involved Lord Byron, a pig who could answer Rice's questions by pawing the ground. This pig was also trained to choose a American flag from others and wave it around.

Eventually Rice starred in his own circus, earning $1,000 a week—a huge amount in those days. He quoted Shakespeare and trained a rope-walking elephant named Lalla Rookh. Unlike Grimaldi, Dan Rice wore little makeup. He sported chin whiskers, a top hat and a striped costume. Thomas Nast, a famous cartoonist, poked fun at Dan Rice's popularity in a caricature that developed into the American symbol Uncle Sam.

Dan Rice later threw his own hat into the political ring and was elected to Congress.

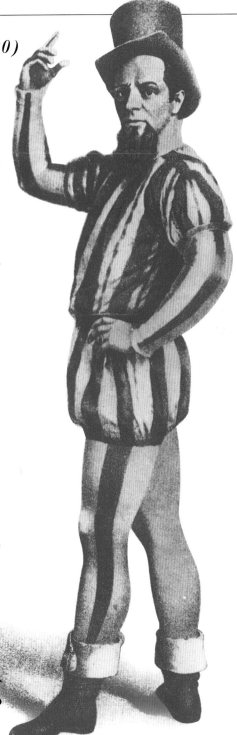

A Red Nose...

Circus historians can't agree on the origin of the one item people most identify with clowns—the big red nose.

Some say it dates back to Greek red-nosed characters who went around sniffing out the dead. Others claim it was first worn by Albert Fratellini, a European clown who played a drunken character in the early 1900s. Still others say that the red nose is evidence of "damage" done when clowns goof around, pretending to knock one another in the face.

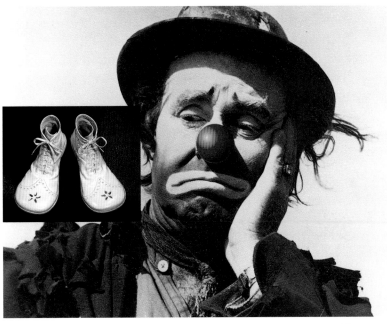

...And Big Toes

Circus performers need special footwear: soft shoes without soles for the acrobats, and boots to protect the motorcyclists. Clown shoes or boots are often custom-made, and it takes practice to walk around in 17-inch-long shoes with 8-inch-wide toes. And the price? More than two hundred dollars for a pair specially ordered with a split toe and worn-down heel!

More clowns! →

Lou Jacobs (1903-1992)

Lou Jacobs performed with the Ringling Bros. and Barnum & Bailey Circus for more than sixty years—a circus record. A contortionist, Jacobs was famous for cramming his six-foot-four frame into a tiny car and driving out into the ring to amaze the audience when he emerged. He carried a real dachshund in a giant hot-dog roll. He played out scenes with his talented Chihuahua, Knucklehead. He took a bath in a self-propelled bathtub. And his pointed head, topped with a small hat, became the face associated with the Big One for years.

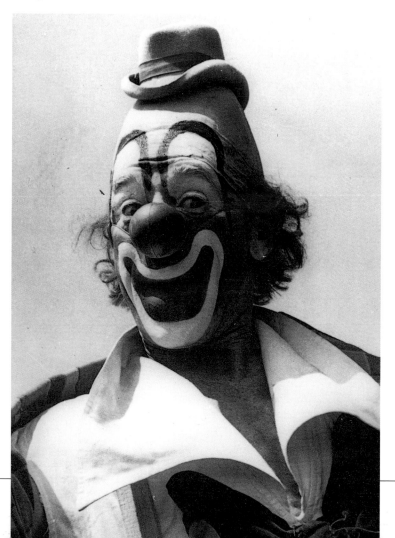

David Larible (1957-)

Italian-born David Larible has worked with the Ringling Bros. and Barnum & Bailey Circus since 1991. He is a seventh-generation circus performer, and his sister Vivien is equally famous, specializing in the Washington trapeze.

Larible, recognized by his checked cap and red nose, often invites members of audience into the ring. Once there, he might cajole someone to jump rope blindfolded. Then he removes the rope, leaving the audience hooting while the person jumps an invisible rope! Or he might give people bells to ring in sequence—but someone's bell doesn't have a clapper. It all seems so effortless and simple, but it isn't.

Peggy Williams (1948-)

It's hard to believe that the "First Lady of Women Clowns" didn't intend to become a clown! Peggy Williams studied speech pathology and planned on a career working with the hearing impaired. She attended Ringling Bros. and Barnum & Bailey Clown College (page 91) to learn more about communicating with her hands, and ended up becoming a popular clown!

Williams's trademark rhinestone teardrops glistened as she performed her various routines. She changed her costume 14,000 times in a two-year season with the Ringling Brothers circus. No wonder she was "always getting zippers fixed"!

Williams worked as a clown for ten years and then moved on into circus management. Today she works in educational programming for the Big One. A constant traveler, Peggy Williams organizes seminars for teachers and works on television and film projects that help people make connections between the circus and their daily lives.

The best thing about being a clown? Williams says, "As a clown, you can go in front of anyone and make their day better. Everyone is in your family! You think like a clown always, and it spills over into your everday life."

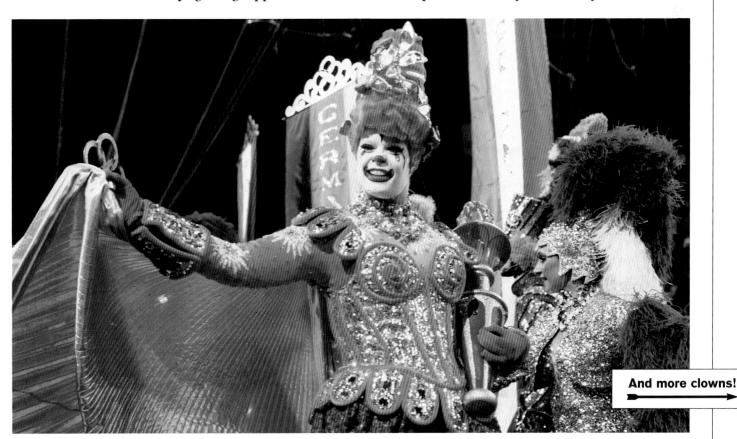

And more clowns! ➡

The Fratellinis: Paul (1877-1940), François (1879-1951), Albert (1866-1961)

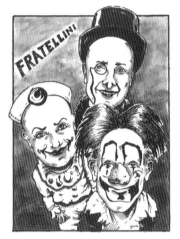

For a long time, the most famous clown act in Europe was that of Paul, François and Albert Fratellini, who performed with the Circus Medrano in Paris in the 1920s. Their Italian father was working as an intern in a psychiatric hospital when he decided that he would be happier performing acrobatics than attending to the sick. Gustave Fratellini soon became a trapeze artist with Circus Mayer.

The brothers were trained in various circus skills and performed individually as acrobats and horseback riders. But during a tour to England, their employer asked François and Albert to perform as clowns one night. Paul joined the act a short time later.

Usually clown acts showcase the skills of one or two clowns; the Fratellinis performed as a trio. Albert wore baggy clothes, wild hair and a nose like a potato (it is said that his makeup inspired Lou Jacobs's famous face design).

François was a white-face clown, with rascally eyebrows and a small hat. Paul dressed "like a lawyer," in a black suit, top hat and monocle. The interaction among the three personalities delighted audiences in Paris, where they were idolized.

The Fratellinis also performed at the famed Cirque d'Hiver, where they developed the musical side of their comic act. Eventually, nearly twenty members of their family, playing jazz, joined them during their performance.

Grock (1880-1959)

Young Adrien Wettach was the son of a Swiss watchmaker. As a small child, he was sent by his family to live and train with a clown family. He grew up to become one of Switzerland's most famous clowns, called Grock.

In the ring, Grock wore a huge overcoat and gigantic boots. His gloves were floppy and his misshapen hat seemed molded to his head. During his act, Grock would try to play different instruments, like the accordion and piano, but he was only successful when he found his tiny violin—then he played a wonderful tune. With his partner, Max, Grock carried on a funny conversation, using phrases like "no kidding." His act lasted for more than an hour.

The famous clown retired in 1954, aged 74. He is remembered each year when the Grock Award is presented to the best clown at the International Festival of Clowning.

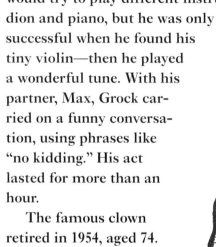

Oleg Popov (1930-)

As a child in Russia, Oleg Popov went to the circus several times, and when he returned home he would imitate the clown acts. He even tried to train the neighborhood cats and dogs for his act, but they fled!

When he was a teenager, Popov got a job at the Pravda Printing Works, and after work he took acrobatics lessons and joined a sports club. Some of his friends wanted to join the circus, and they led him to the state circus school, where he eventually became a student.

Soon Popov learned moves on the slack wire, and he debuted with the circus in 1949. One night during his performance, he heard someone in the audience say, "Young man, you're not a rope walker, you're a clown!" He realized that the man was right, and from then on juggling, acrobatics and rope walking all became part of his clown act.

Oleg Popov's bushy yellow hair, red nose and floppy hat became his trademarks during his many years with the Moscow Circus. He was so admired that he was once followed down the street by Charlie Chaplin. He was called the highest-paid "ambassador" the Soviet circus ever had, even though his acts both ridiculed and supported the government.

Send in the Clowns

Historically, when something goes wrong in the ring (perhaps some equipment needs to be rearranged, or a performer is a few minutes late), the ringmaster sends in the clowns to distract the audience until the matter is cleared up.

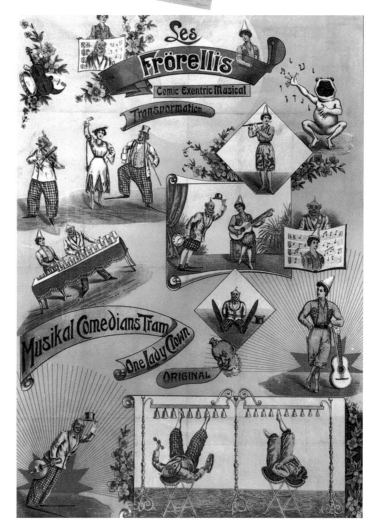

It takes a lot of skill to perform the rubbery stunts of a rodeo or a skating clown (above).

In this late nineteenth-century German poster (left), the Frörellis offer a clown act and some unusual musical interludes.

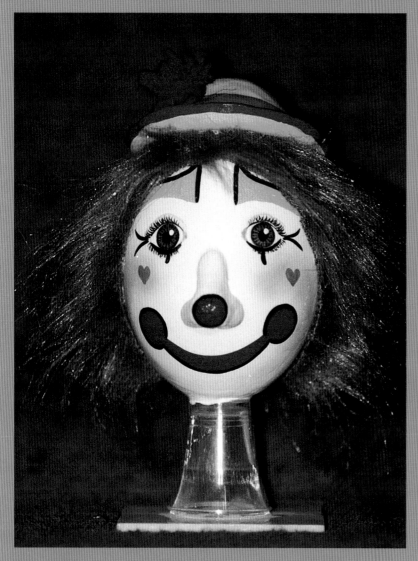
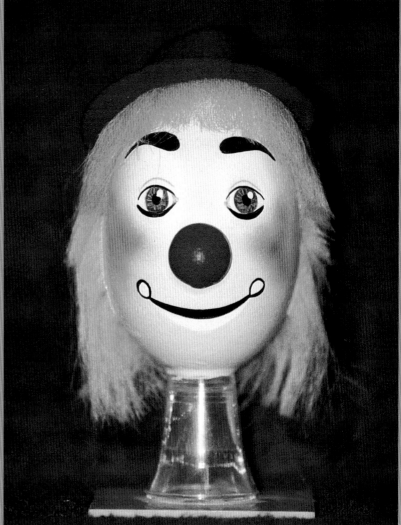

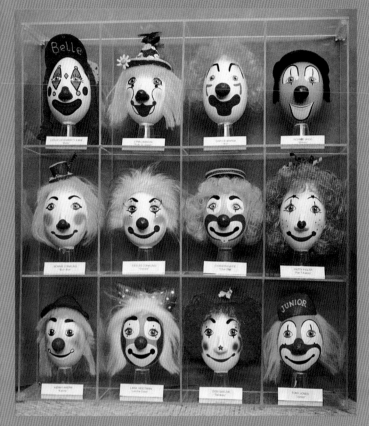

Circus legend has it that a collection of eggs painted with the faces of famous clowns was tragically destroyed by fire long ago. Linda and Leon McBryde of Virginia have honored this tradition by creating their Department of Clown Registry, a collection of more than six hundred eggs that documents for history the faces of male and female clowns from around the world. Linda paints each face on a goose egg and then completes the decoration with a variety of materials. It takes up to a week to create one egg portrait. At left, the clown faces of Kenny Ahern and Marcella Murad ("Mama Clown") show the detailed painting on these eggs, which have toured the world.

Making Faces

Entertainers have been wearing makeup since ancient times. In the early days, the face was sometimes whitened with flour to emphasize large, dark eyes and bright red lips, so everyone in the audience could see each exaggerated facial expression. (Legend has it that a French clown who was a baker by profession was the first to perform with his face white from his job!)

A clown today whitens his face with greasepaint. All the makeup can be ordered from companies whose catalogs advertise everything from "age stipple" and "crepe wool hair" to clown white makeup ("often the choice of performers who entertain at a fast-food restaurant").

A closeup look at a clown's face frightens some people because the eyebrows aren't drawn where they naturally grow, lips are lost in a sea of red, and the hairline is often gone completely. But the face is meant to be seen fifty feet above the ring, and from this distance every feature looks right.

It takes clowns a great deal of practice to create their performance faces. A clown's face is a protected trademark and is never to be exactly copied. It's also considered bad taste for a clown to appear in public partially out of costume, or for a clown to do "normal" things, like eating lunch, while in character.

Circus Controversy #2: Sideshows

Circuses were generally laid out to keep people spending money while they moved toward the Big Top and the main event. One place where people could spend a little extra cash was the sideshow, which was often housed in a separate tent. Outside, colorful banners advertised the "curiosities" that could be seen inside.

Even seventy-five years ago, there was much that people had never seen in their small communities, much of the world that was unexplored and many things that lacked scientific explanations. Businessmen realized early on that people would pay to see anything unusual. Exotic animals were one thing. But the public's curiosity also filled the purses of entrepreneurs who by today's standards were racist and cruelly exploited physically and mentally challenged people.

Other acts featured learned skills, such as fire-eating. Or they showed something a person had elected to do to her body, like tattooing. In the 1800s, when a woman's hair was usually worn up and away from the face, even tightly waved hair was considered quite curious. Cornrows and dreadlocks go unnoticed on our streets today,

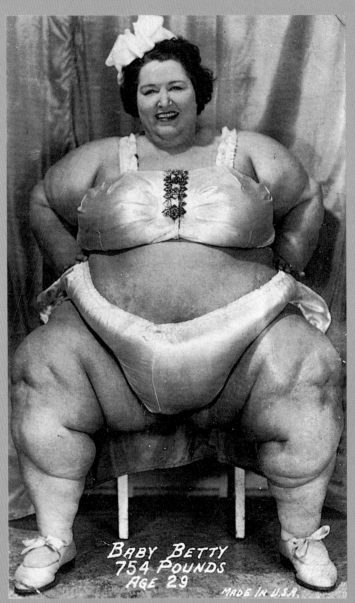

BABY BETTY
754 POUNDS
AGE 29
MADE IN U.S.A.

but they would have been a sensation one hundred years ago.

Many sideshow performers considered themselves artists and entertainers, legitimately making a living doing whatever they could do best, even if it meant sitting in a chair and listening to the comments made by a parade of paying circus customers. And for many, the alternative life would have been unbearable. Society's ignorance, coupled with too little scientific development, meant they would have been locked in a room at home or in an institution. As members of the circus community, many sideshow people enjoyed a protective "family." They had an opportunity to travel the world. Some became superstars. Still, one wonders what kind of compassion was shown to them during their working hours in front of the public.

Today, the public is seemingly better educated, and scientific research has made it possible to remedy many disabilities of the past. However, the sideshow still flourishes around the world, even on the Internet. Our curiosity overcomes our intelligence, and some promoters still supply human spectacles in exchange for cash.

Anna Swan (1846-1888)

Born in Nova Scotia, Canada, Anna Swan was nearly five feet tall when she was five years old, and she kept growing until she was between seven and eight feet tall, depending on different reports.

In New York, P.T. Barnum heard of the giantess and rushed to Nova Scotia to make a deal. It's to Swan's credit that she provided well for herself in the contract. She earned the then princely sum of $1,000 a month, her mother traveled to New York with her, she had a private tutor for three years, and she studied piano and voice. In return, Barnum featured Anna Swan as the "tallest girl in the world." There she sat, dressed in yards of satin and lace, displayed next to the midget Commodore Nutt, who was twenty-nine inches tall.

In 1871, Swan met an American giant, Martin Van Buren Bates, fell in love and married in London. She met Queen Victoria and traveled around Europe. The couple toured with a circus and then settled down to raise horses and cattle on their Ohio farm, built to accommodate their great heights. They had a son and daughter who were both large and died shortly after birth.

None of Anna Swan's twelve brothers and sisters, or her parents, were giants. Giantism can be treated today with surgery, or drugs that slow growth. However, today heights over seven feet are more familiar. You just have to go to a basketball game to watch the latest superstar "giants" we pay to see.

Chang and Eng Bunker (1811-1874)

Joined twins have been called Siamese twins ever since Chang and Eng Bunker were advertised under that name in the early 1800s. They were born in Thailand (Siam), and their names meant "Left" and "Right." They weren't the first joined twins ever born, but they were the first to become so famous.

The identical twins were joined at the lower chest and shared a liver. They reportedly disliked one another and quarreled often. Chang was more aggressive and enjoyed alcohol; Eng was quiet and didn't drink at all.

In the 1850s, the wealthy twins retired from sideshow life, married sisters (some say twins), and lived in two houses on a North Carolina plantation. They spent the week going back and forth between two houses, two wives and the twenty-two children they fathered. The twins died within three hours of each other in 1874.

Depending on how they are joined, Siamese twins today can be separated by lengthy, delicate surgery. While not all of them survive the operation, most go on to lead productive, individual lives.

The circus has always been a splendid mix of action, colors, smells and sounds, rich with history and fantasy. We can't take our eyes off the performers. We watch, envious of every moment the flyer spends suspended like a bird in the air. We sigh with relief when he again stands safely on the cradle.

Artists and writers have always been intrigued by circus life, too. French artists like Renoir, Toulouse-Lautrec, Seurat and Degas lingered in the rings, observing and recording the Parisian circus family. American Alexander Calder captured the motion of the circus in the 1920s with his three-dimensional sculptures made of recycled materials.

And everywhere the circus went, local newspapers covered every aspect of the visit to town, and illustrations accompanied the articles in the days before newspaper photography. Who were these magical and talented people who traipsed the countryside? Everyone wanted to know.

Artworks and written materials have continued to be produced, sometimes by the circuses themselves. Cirque du Soleil, the New Pickle Circus and others have published their own books. And the long tradition of circus autobiographies stretches through time: Mabel Stark (the first woman to train tigers), Emmett Kelly and Gunther Gebel-Williams have produced books that answer many of the questions circus fans continue to ask.

Today, circuses produce videocassettes that provide fans with an "album" of the season's tour. Stores and mail-order catalogs advertise leather jackets, coffee mugs or umbrellas emblazoned with the logo of your favorite circus. And don't forget the pennants, T-shirts, posters, magnets, stickers and balloons sold at the circuses themselves.

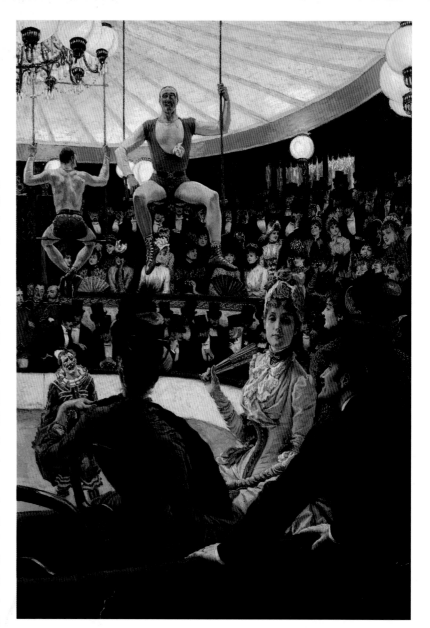

"Women of Paris: The Circus Lover" (1885) by James J. Tissot.

Wallpaper, clothing, toys, footwear, even food (cotton candy, peanuts and pink lemonade) cash in on the circus. Little did Philip Astley dream of the billions of dollars that would be made as his little idea grew through the years!

From 1926 to 1931, sculptor Alexander Calder recycled bits of wire, wood and fabric into his huge (62 in. x 94 in. x 94 in.), fantastical "Circus." Calder moved the many figures, including jugglers, animals and belly dancers, during shows he presented for his friends.

Choreographers have been inspired by the circus's color and motion. The Royal Winnipeg Ballet's repertoire includes "The Big Top," the tale of a young girl who is drawn to the magic of the circus.

Tales of the Big Top

Circus stories for young people either warn of the evils that await a young person who goes to the circus, or portray a marvelous life of endless fun and freedom. Circus novels by famous writers like Noel Streatfeild, Hugh Lofting and Anton Chekhov reflect their own periods of history, attitudes about children and cultural differences. And sometimes a modern reader is disturbed by what the books portray.

Toby Tyler, or Ten Weeks with a Circus, is a good example. The author, James Otis (1848-1912), wrote nearly one hundred children's books, but *Toby Tyler* is his best known. Some say the book encourages young people to follow their dreams. Others argue that it is an account of child abuse.

Young orphan Toby runs off with the circus when it leaves town. What follows are ten weeks of cruelty and pain with brief glimmers of love. Toby is whipped when he's forced to become a bareback rider. He sleeps in the rain. He is cheated. The sideshow people, and a monkey named Mr. Stubbs, comfort him, and in the end Toby returns to his uncle's home, having learned his lesson: "...[you will] be happier than ever, for now you know what it is to be entirely without a home. Be a good boy, mind your uncle, go to school, and one of these days you'll make a good man," says the Skeleton Man.

The way the characters accept Toby's cruel treatment is shocking to modern readers and demonstrates how few rights a child had one hundred years ago. Today, children's rights authorities investigate the use of child performers in the circus to make sure there are no Toby Tylers pressed into service.

"Get your pink lemonade!"

There's a lot of circus folklore, and one of the most colorful tales is about the invention of the traditional drink of the Big Top, pink lemonade.

It seems that enterprising Pete Conklin traveled with the circus and sold lemonade to patrons. Not given to spending wildly, Conklin would float the same weary slices of lemon on the surface of every tubful of watery drink for weeks.

One hot sunny day, sales were so brisk that Conklin ran out of lemonade. Since there were no wells nearby, he had to search the circus lot for water to make some more. In the dressing area of a bareback rider, Conklin spotted a bucketful of water that was slightly pink because a pair of red tights had been rinsed out in it and the dye was not colorfast.

Since no other water was available, and thirsty patrons were waiting to pay for a drink, Conklin took the bucket back to his stand, added sugar and the lemon slices to the pink water and called to his customers to sample the "strawberry lemonade."

Conklin's new drink sold out. And his lemonade batches ever after included a little bit of red dye. Pink lemonade soon became the drink of circuses!

Circus Movies

The Circus (1928)
The most famous tramp of all, Charlie Chaplin, accidentally joins the circus and falls in love with a bareback rider.

Freaks (1932)
This riveting story of revenge, appropriate for a mature audience, portrays a traveling sideshow victimized by a cruel colleague.

Dumbo (1941)
Walt Disney's animated film about a small elephant with gigantic ears, and the friendly mouse who helps him gain self-confidence.

The Greatest Show on Earth (1952)
A Cecil B. DeMille extravaganza, complete with movie stars, real Ringling performers and a spectacular train wreck.

Trapeze (1956)
Young viewers may get bored during the mushy bits, but the trapeze scenes are worth the wait. Real-life acrobat Burt Lancaster stars.

Other films: *La Strada* (1954) and *The Clowns* (1970) by Fellini, *Circus World* (1964) starring John Wayne, and the comedy *Big Top Pee-wee* (1988).

The Circus in Art

The Vesque Sisters:
Marthe (1879-1962) and Juliette (1881-1949)

Children of a French botanist who taught them to draw, Marthe and Juliette Vesque began their professional lives as china painters for the Sèvres company, and later they went to work as illustrators at France's Natural History Museum. From 1903 until 1947, their small watercolor paintings captured minute details of the French circus that they had enjoyed as children. Performers allowed the sisters to record their acrobatic, animal-training and aerial acts, patiently posing in order to assure complete accuracy.

The sisters also documented the inside of the tents (*chapitèaux*), the rings and the daily lives of the performers.

The Vesques agreed never to sell their circus "snapshots." Instead they donated all their work to the Musée des arts et traditions populaires in Paris, where film producers, artists and circus performers and enthusiasts can enjoy their views of the circus past.

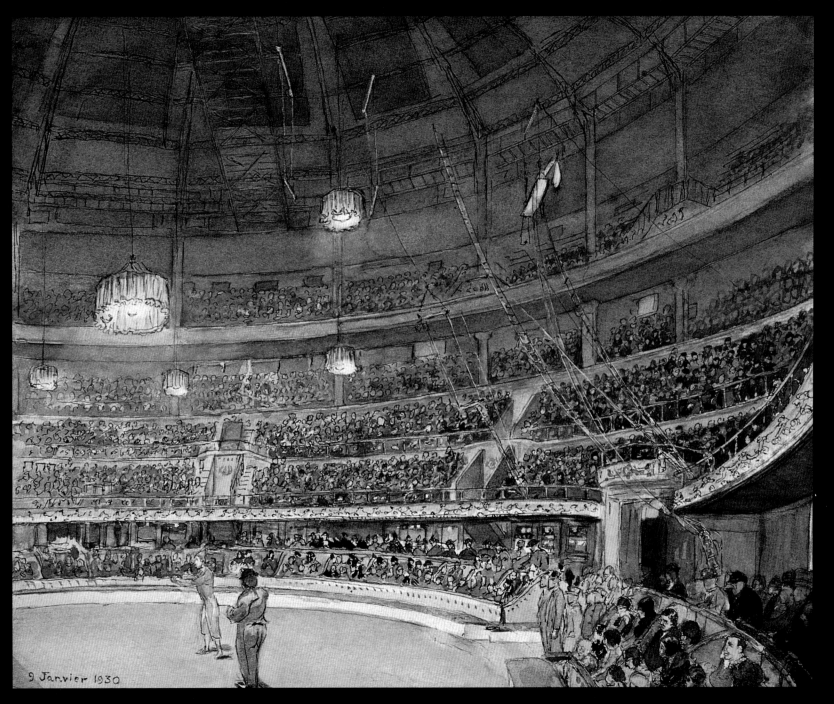

9 Janvier 1930

Bill Ballantine (1910 -)

As boys, American artist Bill Ballantine and his brother made a circus tent on the porch and acted out Big Top performances with their circus dolls. Years later, Ballantine bought a trailer and spent a year following the Ringling Brothers operation, sketching the performers. Famous clowns Harry Dann and Bobby Kaye taught him how to be a clown—half man and half papier-mâché mermaid, complete with tail!

Later, Ballantine became a freelance artist and writer, defining circus life for the readers of magazines like *Collier's* and the *Saturday Evening Post*. Eventually he handled public relations for Ringling and redesigned the front of the circus with modern banners and wagons.

In 1969, Ballantine became the first dean of the Ringling Bros. and Barnum & Bailey Clown College. It was his job to hire the faculty, devise a curriculum and find talented students who could carry on a great, but by then dying, tradition. The college was the first to accept women and black students into a clown program.

In 1977, Ballantine retired as dean, but he has never retired from a life devoted to the circus. He has written books (such as *Clown Alley*) about the circus and continues to draw and paint for books and exhibitions.

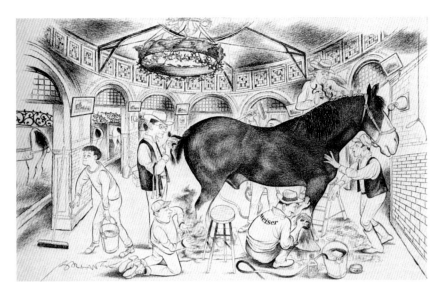

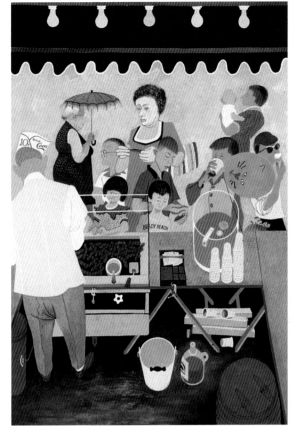

Ballantine's gently caricaturing style captures circus life behind the scenes. At left, "Brooks Bros: Costume Fitting." This page, clockwise from above, "Gussie Busch's Horse, Groomed for a Parade," "Midway Grab and Juice Joint," "Clown College Makeup Room," "Pat Anthony and His Lion." Other Ballantine drawings appear on pages 36, 37, 41, 42 and 56.

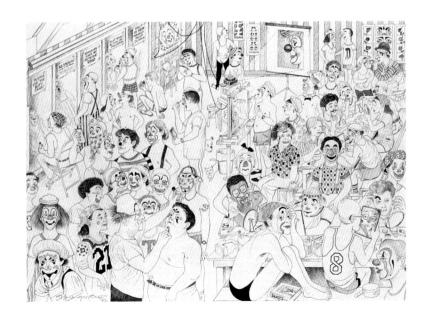

The circus is all around us. We dress up like circus performers on Halloween. Clowns entertain at birthday parties and roam through children's hospital corridors to bring healing laughter to young patients.

Circus summer camps, like the one operated by Circus Smirkus in the United States, and special programs, like Circus Arts in Education run by the Big Apple Circus, teach children the basics of circus life and performance. Resorts like Club Med offer vacationers the opportunity to swing from a trapeze during their holidays. Buskers perform for street crowds, toy stores sell kits for junior jugglers and devil sticks are tossed on school playgrounds.

Every summer, performers from around the world gather for the three-day Bread and Puppet Theater Travelling Circus in Vermont. Juvenalis (page 7) would be pleased to taste the free bread that's given to the audience. It's baked on site and slathered with the troupe's famous garlic spread.

At left, Posy shares some clown antics with Eric during his stay in the hospital.

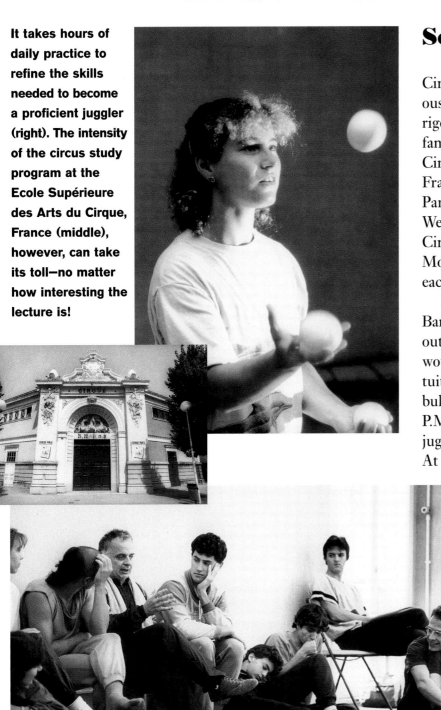

It takes hours of daily practice to refine the skills needed to become a proficient juggler (right). The intensity of the circus study program at the Ecole Supérieure des Arts du Cirque, France (middle), however, can take its toll—no matter how interesting the lecture is!

Serious Studies

Circuses around the world offer classes for those who are serious about a career under the Big Top. Here the training can be rigorous; vacationers are not welcome. Some of the most famous schools include the Ecole Supérieure des Arts du Cirque at Châlons-sur-Marne (the main state circus school in France) and the Conservatoire National des Arts du Cirque in Paris, founded by Alexis Gruss and the first such school in the Western world. There's also Canada's Ecole Nationale de Cirque, the Hungarian Circus School in Budapest and the Moscow Circus School, where three thousand apply for entry each year, and only a few are chosen.

It's tough to get accepted. Applicants to Ringling Bros. and Barnum & Bailey's Clown College, for example, must first fill out a lengthy, detailed application form. About one thousand would-be clowns apply, and only thirty are accepted. In the tuition-free program, the "fledgling funsters," as the college bulletin calls them, take part in classes from 8 A.M. until 10 P.M., six days a week, for eight weeks. They learn acrobatics, juggling, gag development, makeup, prop building and more. At the end of the program, there's the "World's Funniest Final Exam," a two-and-one-half-hour presentation by each student, in front of a judge. Some students are offered contracts to be apprentice clowns with the Big One. Others leave full of hope that another circus will hire them. Some go on to other careers.

Schools and the circus family tradition of passing along skills and knowledge to the newest generation keep circuses provided with new talent. Competitions like the Circus World Championships in Monaco and Le Festival du Cirque de Demain (Festival of the Circus of Tomorrow) in Paris bring together the world's finest performers, who showcase their acts. Recruiters attend the competitions and travel the globe to find unusual acts and new performers to join their circuses.

The Circus Tomorrow

Youngsters enjoy new skills—and plenty of giggles—in Circus Ethiopia.

Will the circus ever disappear? It's not likely. In fact, the circus is finding new ways to grow with our times. It can touch people around the world and speak to them in a universal language.

As part of a program called Jeunesse du Monde (World Youth), basic circus techniques have been taught to homeless street kids in Montreal, Canada, and Rio de Janeiro, Brazil. Through such programs, the kids learn new skills, work together, gain self-confidence and, in the end, stage a performance for other kids in the neighborhood.

A similar program for street kids has resulted, since 1991, in Circus Ethiopia, a troupe of kids aged six to eighteen who come from poor homes in a place where there is very little entertainment for children. Teachers help the kids learn juggling and acrobatics; local customs and dancing are incorporated. Costumes and equipment are donated. Rehearsals are held after school and performances are given for other children. It is estimated that half a million people have seen the performances. And interest is growing. By 1996, there were troupes in five Ethiopian towns.

The circus speaks to our fears and our dreams. It delivers laughter, suspense and escape. It provides a grand spectacle and live excitement that no video or virtual-reality invention can capture—the smells, the feel and the sound of the moment when the aerialist hangs unattached in the air.

And one hundred years from now? Circuses keep changing. Bartabas, the founder of France's Zingaro, argues that his show is a little theater, a little music, a little dance and not at all circus. Ardent circus fans argue it is. Guy Caron of Canada's Cirque du Soleil said the troupe didn't reinvent the circus; they just invented a new combination. Some say it isn't circus; some swear it is. The debate will continue just as circuses like UniverSOUL Big Top of New York are born.

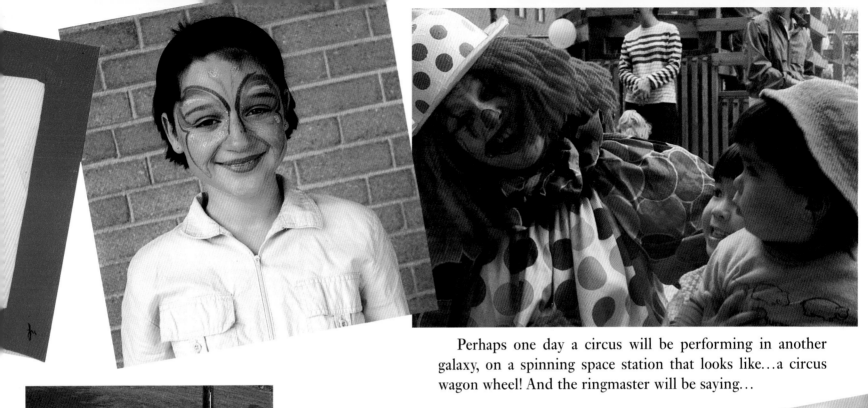

Perhaps one day a circus will be performing in another galaxy, on a spinning space station that looks like...a circus wagon wheel! And the ringmaster will be saying...

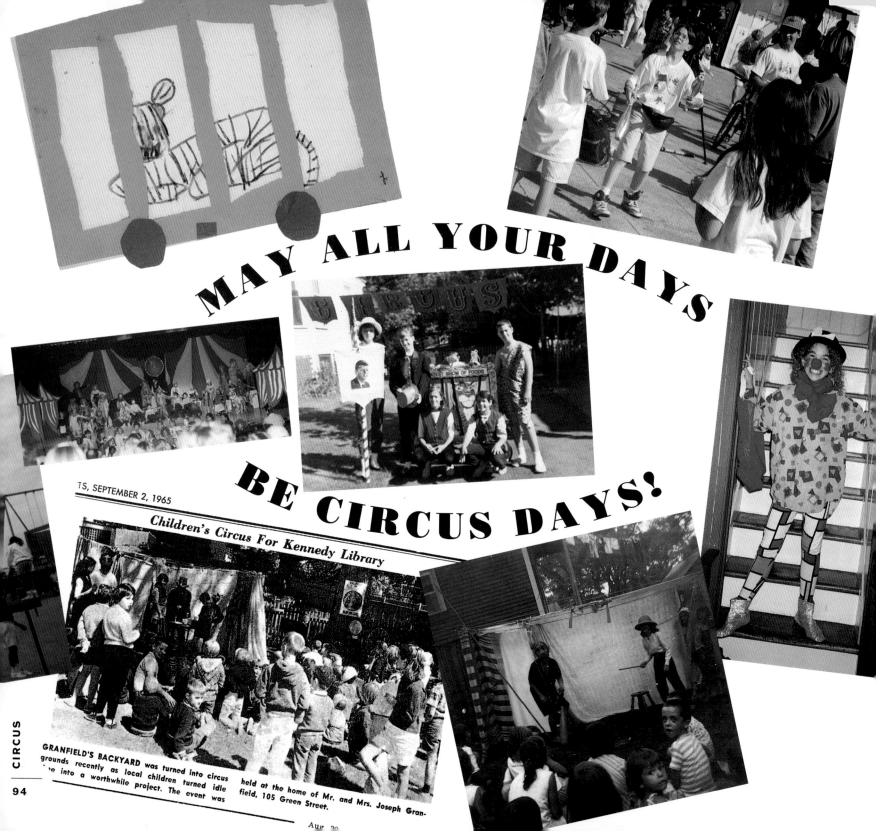

MAY ALL YOUR DAYS

BE CIRCUS DAYS!

Children's Circus For Kennedy Library

GRANFIELD'S BACKYARD was turned into circus grounds recently as local children turned idle ...e into a worthwhile project. The event was held at the home of Mr. and Mrs. Joseph Granfield, 105 Green Street.

Aug. 30.

Index

Picture Credits

Grateful acknowledgment is made to all those who have granted permission to reprint copyrighted material. Every reasonable effort has been made to locate the copyright holders for these images. The publishers would be pleased to receive information that would allow them to rectify any omissions in future printings.

Page 1: Author's collection. Pages 2-3: Author's collection. Page 4 (center): Brundrett's, Victoria, Australia. Page 4 (top right): Musée de la publicité, Paris. Page 5 (top left): Osborne Collection of Early Children's Books, Toronto. Page 5 (left and right): Author's collection. Page 5 (center): Ken Setterington. Page 6: Heraklion Museum, Khania, Crete. Page 7 (top): Piazza Armerina, Sicily, Italy. Page 7 (center): Author's collection. Page 7 (bottom): Archeological Museum of Barcelona, Spain. Page 8: Musée des arts et traditions populaires, Paris. Page 9 (top): Courtesy of the George R. Gardiner Museum of Ceramic Arts, Toronto. Page 9 (bottom): Osborne Collection of Early Children's Books, Toronto. Page 10: The National Portrait Gallery, London. Page 11 (left): Dover Publications Inc., New York. Page 11 (right): The National Portrait Gallery, London. Page 12 (left): David Rolfe. Pages 12-13: Historical Collections, Bridgeport Public Library, Connecticut. Page 14: Dover Publications Inc., New York. Page 15 (left): The John & Mable Ringling Museum of Art, Sarasota, Florida. Page 15 (right): Circus World Museum, Baraboo, Wisconsin. Page 16: Dover Publications Inc., New York. Page 17 (left): #9627 courtesy of The Peabody Essex Museum, Salem, Massachusetts. Page 17 (top right): Dover Publications Inc., New York. Page 17 (bottom right): David Rolfe. Page 18: Circus World Museum, Baraboo, Wisconsin. Page 19 (left): Circus World Museum, Baraboo, Wisconsin. Page 19 (right): Patsy Aldana. Page 20 (top): Circus Krone. Page 20 (bottom): Circus Roncalli. Page 21: Andrew Stawicki, Toronto *Star*. Page 22 (both): Historical Collections, Bridgeport Public Library, Connecticut. Page 23: Historical Collections, Bridgeport Public Library, Connecticut. Page 24: Osborne Collection of Early Children's Books, Toronto. Page 25: Circus Knie. Page 26: The John & Mable Ringling Museum of Art, Sarasota, Florida. Page 27 (top): The John & Mable Ringling Museum of Art, Sarasota, Florida. Page 27 (bottom): Author's collection. Page 28 (all): Jane Buss. Page 29 (both): Musée des arts et traditions populaires, Paris. Page 30 (background): The John & Mable Ringling Museum of Art, Sarasota, Florida. Page 30 (inset): Author's collection. Page 31(top left inset): Author's collection. Page 31 (bottom left inset): Musée de la publicité, Paris. Page 31 (right and top right inset): Campbell S. King. Page 32 (left): The John & Mable Ringling Museum of Art, Sarasota, Florida. Page 32 (bottom): Author's collection. Page 33 (upper left): Lynn Westerhout Cutler. Page 33 (lower left): Ron Jobe. Page 33 (upper right): Dover Publications Inc., New York. Page 33 (inset): The John & Mable Ringling Museum of Art, Sarasota, Florida. Page 34: The John & Mable Ringling Museum of Art, Sarasota, Florida. Page 35 (upper left): Big Apple Circus, photo by Patricia Lanza. Page 35 (left center and right): Author's collection. Page 36: Bill Ballantine. Page 37 (left): Bill Ballantine. Page 37 (right): The John & Mable Ringling Museum of Art, Sarasota, Florida. Page 38 (top): Robert Sugarman. Page 38 (bottom): The John & Mable Ringling Museum of Art, Sarasota, Florida. Page 39 (both): Author's collection. Page 40: Historical Collections, Bridgeport Public Library, Connecticut. Page 41 (top left): Big Apple Circus, photo by Patricia Lanza. Page 41 (top right and bottom right): Robert Sugarman. Page 41 (bottom left): Bill Ballantine. Page 42: Bill Ballantine. Page 43: Author's collection. Page 44 (left): Jan Shoor Potter. Page 44 (right): Bill Ballantine. Page 45: Cirque du Soleil, photo by Al Seib. Page 46 (all): Author's collection. Page 47 (left): Circus Roncalli. Page 47 (right): The John & Mable Ringling Museum of Art, Sarasota, Florida. Page 48 (top left): Osborne Collection of Early Children's Books, Toronto. Page 48 (bottom left): Big Apple Circus, photo by Theo Krath. Page 48 (top right): Author's collec-

tion. Page 49: Cirque du Soleil, photo by Al Seib. Page 50: Musée des arts et traditions populaires, Paris. Page 51: Osborne Collection of Early Children's Books, Toronto. Page 52: Author's collection. Page 53 (both): Mike Carroll. Page 54 (top and bottom): Circus World Museum, Baraboo, Wisconsin. Page 55: The John & Mable Ringling Museum of Art, Sarasota, Florida. Page 56 (left): Jane Buss. Page 56 (top right): Bill Ballantine. Page 57 (top): Culver Pictures, New York. Page 57 (bottom): Musée de la publicité, Paris. Page 58: Osborne Collection of Early Children's Books, Toronto. Page 59 (left): Author's collection. Page 59 (right): Jane Buss. Page 60 (top): Author's collection. Page 60 (bottom): #16,382 courtesy of Peabody Essex Museum, Salem, Massachusetts. Page 61 (bottom left): Historical Collections, Bridgeport Public Library, Connecticut. Page 61 (bottom right): Author's collection. Page 62 (top): Author's collection. Page 62 (bottom): The John & Mable Ringling Museum of Art, Sarasota, Florida. Page 63 (top right): The John & Mable Ringling Museum of Art, Sarasota, Florida. Page 63 (center right): Osborne Collection of Early Children's Books, Toronto. Page 63 (bottom): Patsy Aldana. Page 64 (top): Author's collection. Page 64 (bottom): Osborne Collection of Early Children's Books, Toronto. Page 65: Musée de la publicité, Paris. Page 66 (left): Circus World Museum, Baraboo, Wisconsin. Page 66 (right): David Rolfe. Pages 66-67 (bottom): Circus World Museum, Baraboo, Wisconsin. Page 67 (top and bottom): photos courtesy of Ringling Bros. and Barnum & Bailey Combined Shows. Page 68 (top left): Brian Dube, Inc., New York. Page 68 (center left): Author's collection. Page 68 (bottom left): Robert Sugarman. Page 68 (top right): Osborne Collection of Early Children's Books, Toronto. Page 68 (bottom center): Musée de la publicité, Paris. Page 68 (bottom right): Cirque du Soleil photo by Al Seib. Page 69 (top left and bottom left): Robert Sugarman. Page 69 (top right): Jane Buss. Page 69 (center-both): Patsy Aldana. Page 69 (bottom right): Brian Dube, Inc., New York. Page 70: Circus World Museum, Baraboo, Wisconsin. Page 71 (both): Author's collection. Page 72: National Portrait Gallery, London. Page 73 (left): Circus World Museum, Baraboo, Wisconsin. Page 73 (right): Author's collection. Page 73 (inset): The Bata Shoe Museum, Toronto. Page 74 (left): Circus World Museum, Baraboo, Wisconsin. Page 74 (right) photo courtesy of Ringling Bros. and Barnum & Bailey Combined Shows. Page 75: photo courtesy of Ringling Bros. and Barnum & Bailey Combined Shows. Page 76 (both): David Rolfe. Page 77 (top right): Don Cribar. Page 77 (bottom right): Musée des arts et traditions populaires, Paris. Page 77 (top left): Culver Pictures, New York. Page 78: Linda and Leon McBryde. Page 79 (left): Linda and Leon McBryde. Page 79 (top center and top right): Ben Nye Co. Inc., Los Angeles. Page 80: Author's collection. Page 81 (top center): Courtesy of the History Collection, Nova Scotia Museum, Halifax. Page 81 (bottom center): Historical Collections, Bridgeport Public Library, Connecticut. Page 82: Juliana Cheney Edwards Collection, courtesy, Museum of Fine Arts, Boston. Page 83 (bottom): Courtesy of the Whitney Museum of American Art, New York. Page 83 (top): Royal Winnipeg Ballet, photo by David Cooper. Page 84 (all): Osborne Collection of Early Children's Books, Toronto. Page 85 (left): Michael Solomon. Page 85 (right): Author's collection. Page 86: Musée des arts et traditions populaires, Paris. Page 87: Musée des arts et traditions populaires, Paris. Pages 88-89: Bill Ballantine. Page 90 (left): Collection of Posy, courtesy of Abe & Sue Thiessen. Page 90 (right-both): Shari Siamon. Page 91(all): Mike Carroll. Page 92 (top left-both): Catherine Bush. Page 92 (top right and bottom): Author's collection. Page 93 (top left): Author's collection. Page 93 (top right, bottom left, bottom center): Shelley Tanaka. Page 93 (bottom right): Cal Smiley. Page 94 (top left, center, center left, bottom left, bottom right): Author's collection. Page 94 (top right): Camilla Gryski. Page 94 (center right): Shelley Tanaka.